IMAGES
of America

MUSCATINE'S
PEARL BUTTON INDUSTRY

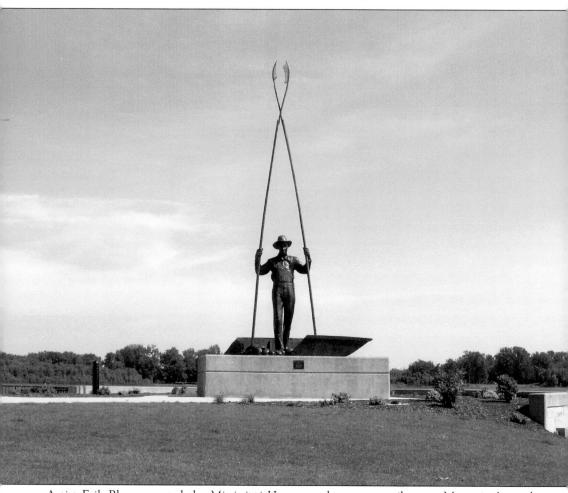

Artist Erik Blome created the *Mississippi Harvest* sculpture as a tribute to Muscatine's pearl button industry. The twice-life-size sculpture was installed on the Muscatine riverfront in 2006 as part of the town's Pearl of the Mississippi project. The bronze sculpture was based on a historic photograph from the Muscatine Art Center's collection.

On the Cover: The U.S. Button Company documented the process of turning shells into finished buttons with a series of factory photographs taken around 1915. The factory, operating from 1913 to 1941, was one of a dozen companies that made finished buttons in Muscatine. Ladd Steinmetz, whose father was one of four partners at the company, donated this photograph and others in the series. (Courtesy of Muscatine History and Industry Center.)

IMAGES
of America

MUSCATINE'S
PEARL BUTTON INDUSTRY

Melanie K. Alexander

ARCADIA
PUBLISHING

Published by Arcadia Publishing
Charleston, South Carolina

Printed in the United States of America

Library of Congress Catalog Card Number: 2007929509

For all general information contact Arcadia Publishing at:
Telephone 843-853-2070
Fax 843-853-0044
E-mail sales@arcadiapublishing.com
For customer service and orders:
Toll-Free 1-888-313-2665

Visit us on the Internet at www.arcadiapublishing.com

*For the thousands of people whose lives were touched by the
pearl button industry and for the Historic Muscatine Incorporated
founders who have preserved Muscatine's pearl button past.*

CONTENTS

ACKNOWLEDGMENTS

Countless individuals and organizations have helped to bring this book to fruition. In 2006, the Muscatine History and Industry Center opened a new exhibition on the pearl button industry. The over 100 people, corporations, and foundations that supported the exhibition through their leadership, vision, and financial contributions are in part responsible for making the resources available to complete this book. While working on the exhibition, countless personal stories, stunning photographs, and surprising facts were uncovered. This book has provided an outlet for sharing some items that had to be cut from the exhibition itself.

Thank you to all the individuals who have donated photographs, documents, and artifacts to the pearl button collection. Ladd Steinmetz's collection of photographs from the U.S. Button Company makes up the core of Chapter 5. In addition to the Muscatine History and Industry Center's collection, numerous individuals and organizations have given permission to reproduce their photographs. Nancy Keel's collection captured the daily lives of men working in cutting shops and clammers and their families. The Musser Public Library and the Muscatine Art Center have provided many additional images.

The research of many individuals also laid the foundation for this book. In particular, the work of Dr. Jennifer Pustz made Chapter 6 possible. My personal understanding of the button industry has been shaped by all the former button workers and clammers who have told me their personal stories, including Charles "Mick" Hagermann, Iris Bauerbach, Ruth Phillips, and Clarence Lick. I would also like to thank the individuals who began recording oral histories of button workers decades ago. The current button factories in Muscatine—J and K Button Company, McKee Button Company, and Weber and Sons Button Company—have also been important sources of information.

For their support of this project, thank you to all the members of the Historic Muscatine Incorporated board of directors, including Kathy Keane Bankhead, Tom Bankhead, Max Churchill, Clyde Evans, Mark Huddleston, Scott Lesnet, and Jim Nepple.

INTRODUCTION

Industry in Muscatine has depended upon the area's natural resources, fertile ground, and location on the Mississippi River. The area's plentiful woods established Muscatine as a lumber town. However, it was the modest shell lying thick on the river bottom that made the town's most famous product—the pearl button.

By 1905, Muscatine produced 1.5 billion pearl buttons annually. With nearly 37 percent of the world's buttons coming from Muscatine, the town became the undisputed "Pearl Button Capital of the World." A popular local saying claimed, "No Muscatine resident can enter Heaven without evidence of previous servitude in the button industry."

The rise and fall of the pearl button occurred over a period of 75 years. At its height, the cutting-edge automated industry employed half the local workforce. Decades later, the American-made pearl button buckled under the pressure of foreign competition, changing fashion, limited availability of shell, and the development and refinement of plastic buttons.

John Frederick Boepple, a German immigrant button maker, launched Muscatine's pearl button industry in 1891. The button industry and the mussel fishing, or "clamming" business, started small, but within a few years, clamming became the Mississippi River's gold rush. Clammers harvested less than 100 tons of shell in 1894. By 1897, the amount had grown to 3,500 tons. Two years later, clammers took nearly 24,000 tons. As early as 1908 and continuing into the 1920s, the industry averaged between 40,000 to 60,000 tons of shell annually at a value of $800,000 to over $1 million.

The pearl button industry reached into the homes and lives of Muscatine residents. The humming noise of cutting machines echoed throughout entire neighborhoods while piles of cut shell and soaking barrels lined the alleyways. Inside the home, women and children helped support their families by sewing buttons on cards.

The widely used term "button factory" generally included shops of all size and functions. True factories producing finished buttons made up only a small percentage of the shops. These were known as finishing plants. Small operations, called saw works and cutting shops, employed from two or three men up to a few dozen and produced only rough button blanks. While large factories included cutting departments, these same factories also depended upon small shops to provide additional rough button blanks.

Men, women, and children found employment in the button business. For workers, standing at a noisy, dangerous machine 10 hours a day, six days a week did not guarantee a decent wage. For management, the workers' finished product did not guarantee a profit. Flawed finished product could not be sold at a good price, and expenses such as wages, raw materials, and equipment accumulated.

Button workers first unionized in 1899, and a few cutting shops launched unsuccessful strikes in 1899 and 1900. By 1910, Muscatine workers seriously questioned the practices of factory owners and formed a powerful union capable of confronting management. In 1911, Muscatine button workers began a strike that affected thousands of men, women, and children at most factories and cutting shops. By the time the labor dispute concluded in 1912, Gov. Beryl Franklin Carroll had called the state militia to Muscatine on two separate occasions and one police officer had been fatally shot while on duty. The bitterness of the 1911 strike stayed with Muscatine residents for years to come. The only other notable strike occurred in 1938, and it remained confined to a single factory.

Two key factors had turned Muscatine into the "Pearl Button Capital of the World"—Boepple's launch of the industry and the machines invented by the Barry family of Muscatine. After touring a button shop located near their father's plumbing business, John and Nicholas Barry knew they could make better machines. Their invention, the Barry Automatic, was a large machine that drilled button holes. Another machine carved the design on the face of the button. By 1904, these functions were combined into one machine known as the Double Automatic. These two machines made a standardized button, allowed for increased production, and were as revolutionary as the McCormick reaper and Whitney cotton gin. The work of seven cutting machines supplied one Double Automatic, capable of producing over 150 gross or 21,600 buttons per day. Eventually the Barrys became the main supplier of button making machinery, not only in Muscatine, but across the country.

Muscatine made more from mussel shell than billions of buttons. Ordinary items such as buckles, fishing lures, tableware, and other novelties became treasured pieces when made from iridescent shell. Muscatine native George Gebhardt saw potential in leftover shell and turned his Universal Shell Company into a half-million-dollar business. Gebhardt marketed his animal feed supplement to farmers and developed creative crushed shell products for fish bowls, stucco, and powder to line athletic fields.

Although products made from shell were beautiful and useful, the pearl button industry could not continue in perpetuity. Availability of the shell, changes in fashion, foreign competition, and the development of durable plastic materials brought the end of the pearl button era.

Early experiments with plastic buttons began in the 1920s. During World War II, technological advancements brought better plastic buttons. The switch from pearl to plastic did not occur over night. Plastic button blanks were turned into finished buttons on modified Barry machines. In the 1950s and 1960s, many Muscatine factories made freshwater pearl, ocean pearl, and plastic buttons simultaneously. Touted for their pearl-like qualities, plastic buttons attempted to provide the look of pearl at a fraction of the cost. By the late 1960s, companies in Muscatine ceased all production of pearl buttons. A handful of local companies continue Muscatine's button-making legacy, but they no longer receive shipments of shell. Their raw material arrives in the form of polyester syrup in large drums.

By the time the button boom ended, other industries had established themselves in Muscatine. Homegrown companies such as Stanley Consultants Incorporated, Kent Feeds and Grain Processing Corporation of Muscatine Foods, Carver Pump Company, HNI Corporation, Bandag, and Musco Lighting have gained national recognition while remaining committed to the Muscatine community. Large operations such as H. J. Heinz Company, Monsanto Company, and IPSCO Steel Company have chosen the area for branch plants. Although Muscatine's economy is no longer tied to mussel shell, local people have found numerous ways to remember its pearl button past.

One

MUSCATINE BEFORE BUTTONS

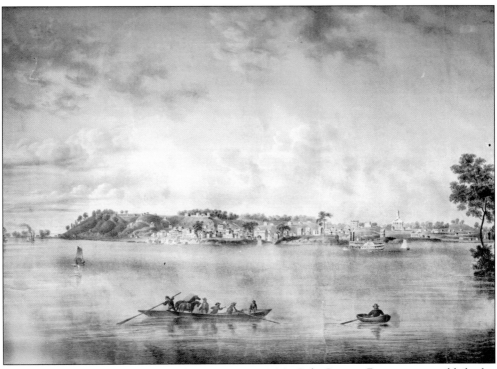

BLOOMINGTON—LATER NAMED MUSCATINE, 1845. Col. George Davenport established a trading post in 1834 in the area. The town was laid out and given the name Bloomington in 1836. The name change to Muscatine came in 1849. The following year, Muscatine had a population of over 2,500. (Courtesy of Musser Public Library.)

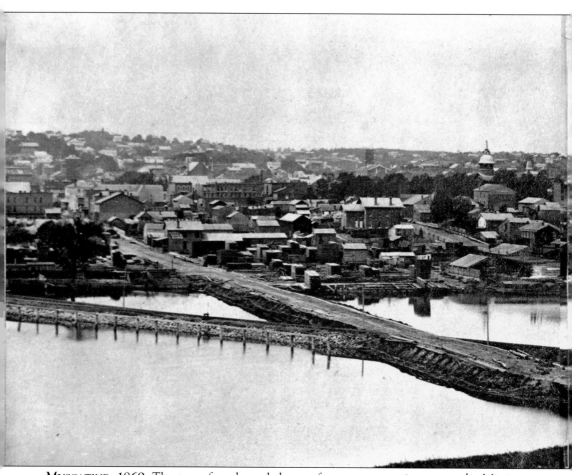

MUSCATINE, 1869. The town first depended upon ferry transportation across the Mississippi River. It was not until 1891 that a bridge connected Muscatine to Illinois. The last half of the 19th century provided opportunities for vast fortunes to be made. Commercial businesses settled

into the heart of Muscatine. Homes were built on the bluffs flanking the downtown. Prosperity came to several Muscatine men who established sawmills. The lumber industry employed hundreds of workers, boosting the town's economy. (Courtesy of Musser Public Library.)

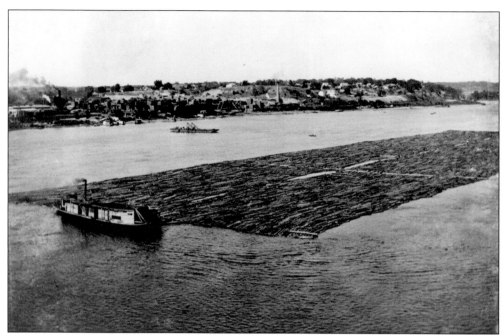

LOG RAFT ABOVE MUSCATINE HIGH BRIDGE, 1901. In 1835, James Casey found that lumber was in demand. He established Casey's Wood Pile on the river to supply steamboats with lumber. Later sawmills and sash and door companies became part of Muscatine's landscape. (Courtesy of Musser Public Library.)

HERSHEY'S UPPER MILL, c. 1890. Benjamin Hershey moved to Muscatine in 1855 and launched a lumber mill two years later. Hershey formed a partnership with S. G. Stein and incorporated the Hershey Lumber Company in 1875. By 1889, the two men operated two large mills in Muscatine and a third in Stillwater, Minnesota. (Courtesy of Musser Public Library.)

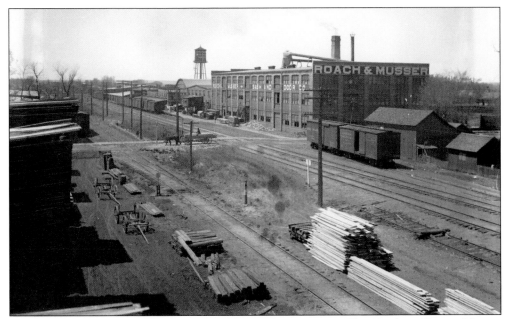

ROACH AND MUSSER SASH AND DOOR COMPANY, C. 1900. The Hershey, Huttig, Musser, and Roach families played central roles in Muscatine's lumber industry. The Huttig brothers purchased a Muscatine lumberyard in 1868 and expanded it to Kansas City and St. Louis. The Mussers had acquired a lumber business in Muscatine in 1889. This business was reincorporated as Roach and Musser Sash and Door Company. (Courtesy of Musser Public Library.)

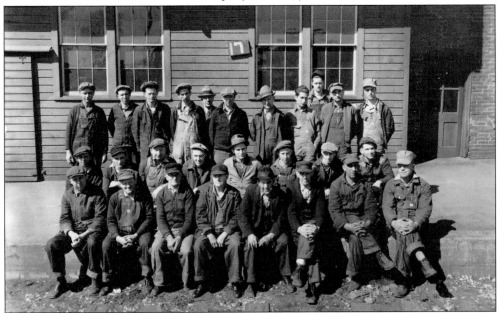

EMPLOYEES OF ROACH AND MUSSER SASH AND DOOR COMPANY, 1938. Even as the declining lumber supply and increasing shipping costs forced many lumber mills to close, the Roach and Musser Sash and Door Company remained strong. The company was one of Muscatine's largest employers until 1957 when it was purchased by a New York firm. (Courtesy of Muscatine History and Industry Center.)

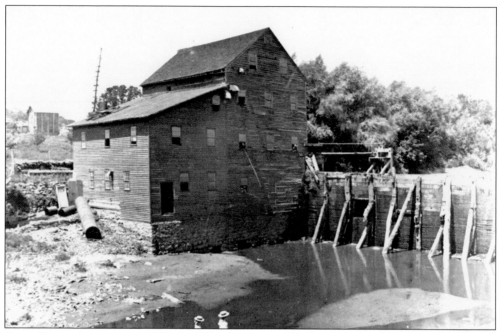

PINE CREEK GRISTMILL, 1899. In 1834, Benjamin Nye became the first permanent settler in Muscatine County. Nye operated an early lumber mill and built a gristmill in 1848, located about 12 miles from Muscatine in what is now Wildcat Den State Park. (Courtesy of Musser Public Library.)

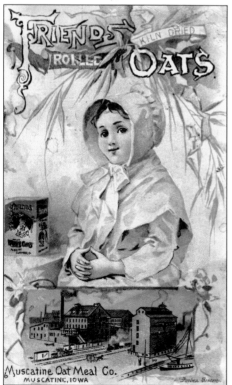

MUSCATINE OAT MEAL COMPANY, C. 1885. One of Muscatine's oldest existing structures was originally Bennett's Flour Mill, built in 1849. From 1879 to 1902, the Muscatine Oat Meal Company made cereal here, marketed as Friend's Oats brand. The mill continued to produce cereal until 1917. The building later housed a pearl button factory. (Courtesy of Tom and Ann Meeker.)

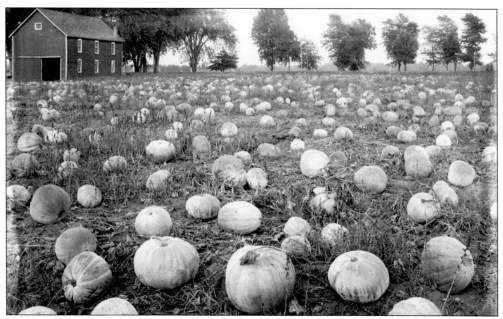

E. G. HOOPES'S PUMPKIN FIELD, 1912. An area south of town, known as Muscatine Island, provided excellent conditions for growing melons and other produce. When William H. Hoopes purchased farmland in 1876, his plan was to supply markets beyond the Muscatine area. His 150 acres of rich soil produced watermelons, cantaloupes, tomatoes, sweet potatoes, pumpkins, cabbage, and more. (Courtesy of Musser Public Library.)

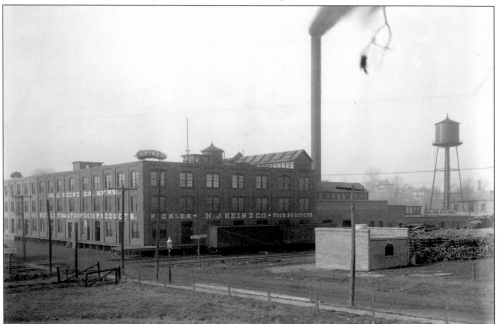

H. J. HEINZ PLANT IN MUSCATINE, 1914. In 1892 the H. J. Heinz Company chose Muscatine as the location of its first branch manufacturing plant outside of Pittsburgh. The factory once employed 1,000 people plus many others who worked the company's farm located on Highway 22. (Courtesy of Musser Public Library.)

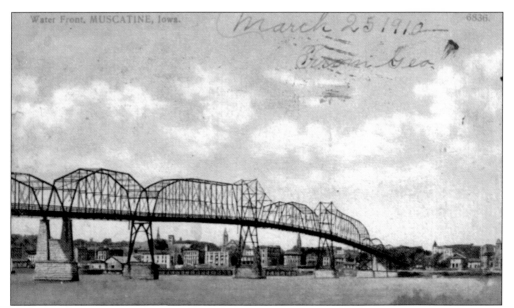

MUSCATINE HIGH BRIDGE, C. 1910. A group of local businessmen formed the Muscatine Bridge Company in 1888. Their plan of building a bridge to span the Mississippi River at Muscatine was financed by stock subscription and issued bonds. The bridge, completed in 1891, was a cantilever construction with six spans that made up its half-mile of length. (Courtesy of Muscatine History and Industry Center.)

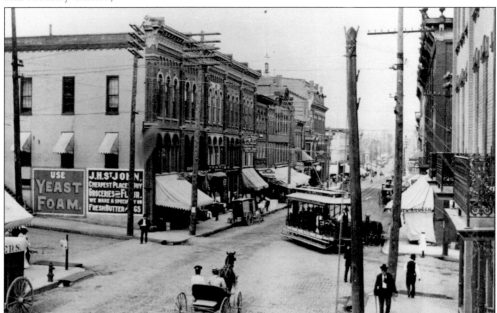

SECOND STREET, EAST OF CHESTNUT STREET, C. 1900. In the late 1800s and early 1900s, Muscatine was a growing town. Many Germans and their descendents had settled in or had been born in Muscatine. The 1910 census documented that 63 percent of the town's foreign-born residents and 47.6 percent of native-born residents with foreign parents were German. Germans and their interest in button making transformed Muscatine. (Courtesy of Musser Public Library.)

Two

A Little Imagination, A Little Mussel

BOEPPLE BUTTON COMPANY ADVERTISEMENT, 1900. John Frederick Boepple, an immigrant button maker, launched Muscatine's pearl button industry in 1891. Tariff changes had caused his button business in Germany to fail. Remembering the excellent shell shipped from America, Boepple began his search for mussel shells in Illinois. Popular legend claims that Boepple finally found shell when he cut his foot while bathing in the Sangamon River. (Courtesy of Muscatine Art Center.)

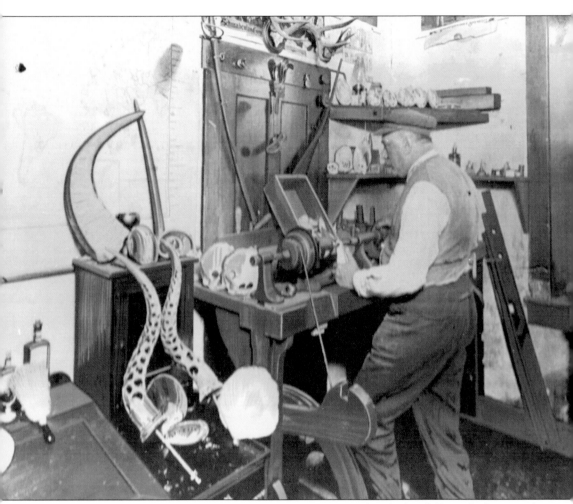

BOEPPLE WORKING AT A FOOT-POWERED LATHE, C. 1891. John Frederick Boepple discovered that some shells, like those in the Sangamon River, were too fragile to withstand cutting. His search continued and finally ended in Muscatine where tough, thick mussel shell was abundant in the Mississippi River. Boepple later recalled the experience, "At last I found what I had been looking for; yet there still was a problem before me. I was without capital in a strange land and unfamiliar with the language." Early button machines were foot-powered and performed multiple tasks from cutting the shell and carving the design to drilling the holes. Boepple adapted ocean pearl machines for freshwater mussel shell. By the time Boepple established his first shop, the McKinley tariff of 1890 had made imported ocean shell expensive. Conditions were ideal for what many in Muscatine originally considered the foolish dreams of a strange man speaking broken English. (Courtesy of Muscatine Art Center.)

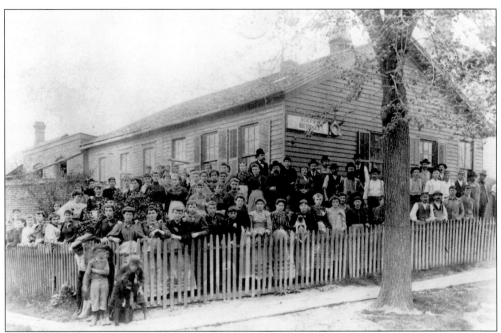

BOEPPLE'S FACTORY AT SIXTH AND LINN STREETS, 1895. After securing a financial partner, William Molis of Muscatine, Boepple opened the world's first freshwater pearl button plant in 1891. A few years later, Boepple expanded into a two-story building, designed especially for manufacturing pearl buttons. (Courtesy of Musser Public Library.)

PAY ENVELOPE FROM BOEPPLE BUTTON COMPANY, c. 1900. The industry appeared more viable as Boepple's new factory transitioned from foot-powered lathes to machines connected to a steam engine by line shafts. With a promising future for the freshwater pearl button industry, entrepreneurs took interest in button cutting and mussel fishing. Only six years after the industry's launch, dozens of button cutting shops were operating in Muscatine. (Courtesy of Muscatine Art Center.)

M _Lena Miller_

Week Ending_____

$_____

Boepple Button Co.
MUSCATINE, IOWA.

STYLISH

UNION MADE SHOES,

20 New Styles to select from for men, women and children, cost no more than others and wear much better.

Leysen's Shoe Store.

(OVER)

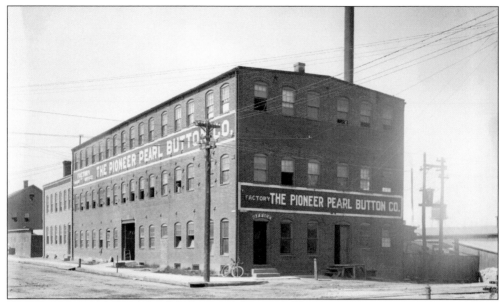

PIONEER BUTTON COMPANY, 1909. John Frederick Boepple and his partners built a large plant at 701 East Third Street. Boepple remained attached to his old world ideals and opposed automation. His partners, wanting to modernize, convinced Boepple to set up another factory in Davenport. Despite a nasty parting, his partners continued to imply the founder's involvement through their new company's name—the Pioneer Button Company. (Courtesy of Musser Public Library.)

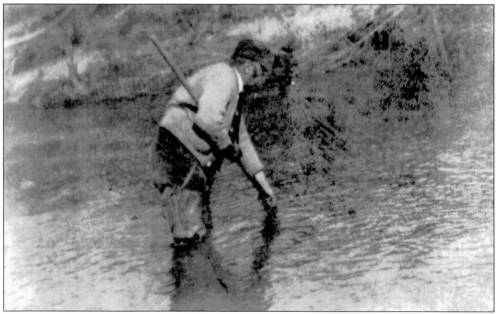

BOEPPLE GATHERING MUSSELS, 1911. In 1910, Boepple became a mussel expert for the newly established Fairport Biological Station. While working a river in Indiana during the fall of 1911, Boepple reportedly stepped on a shell, cutting his foot and causing a blood infection. Hospitalized in Muscatine, Boepple died on January 30, 1912. The town's mayor asked all businesses to close during Boepple's funeral service. (Courtesy of Muscatine Art Center.)

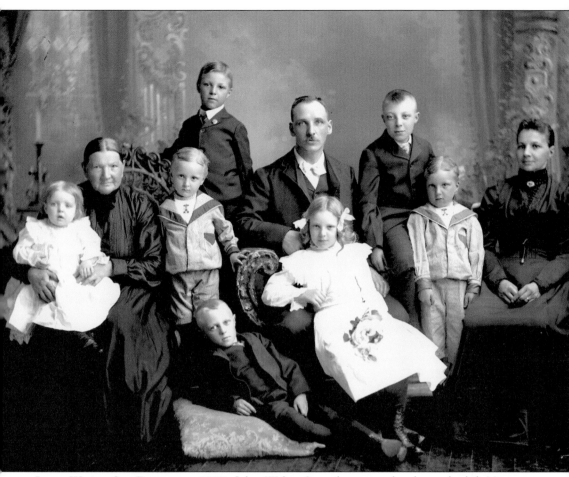

JOHN WEBER SR. FAMILY, C. 1902. John Weber Sr., a button maker by trade, left Vienna, Austria, in 1892. Like Boepple, Weber could no longer make a living in Europe thanks to the American tariff on buttons. Settling first in Philadelphia, Weber was convinced by Boepple to move to Muscatine. After a few months working with Boepple, Weber became involved with Royal Button Manufacturing and, later, the Automatic Button Company. Weber established his own button business in 1904 and constructed a much expanded facility in 1915 on East Sixth Street, providing employment for 150 to 200 people. The Weber family has now operated Weber and Sons for over 100 years. From left to right are (first row) Margaret Weber, being held by her maternal grandmother Franciska Kukacka; Walter Weber; John Weber Jr., lying on the floor; and Minnie Weber, sitting in the chair; (second row) Charles Weber; John Weber Sr.; Louis Weber; William Weber; and Franciska Weber. (Courtesy of Musser Public Library.)

FREDERICK C. VETTER, C. 1910. John Frederick Boepple and Frederick C. Vetter met while serving in the Franco-Prussian War. Once both men were settled in Muscatine, Boepple taught Vetter the button business. Vetter was one of four men who launched the Hawkeye Button Company in 1902. (Courtesy of Charles and Shirley Hagermann.)

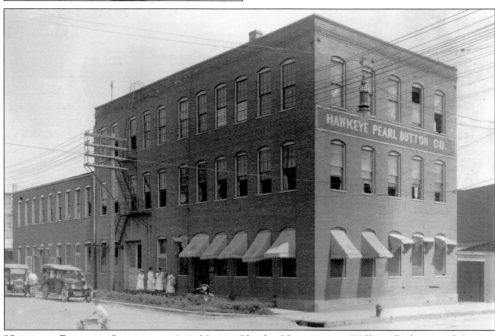

HAWKEYE BUTTON COMPANY, 1917. Vetter, Charles Hagermann, William Bishop, and George Jackson turned the Hawkeye Button Company into one of Muscatine's largest producers of pearl buttons. By 1911, the company employed 800 people and had offices in New York City and St. Louis. (Courtesy of Musser Public Library.)

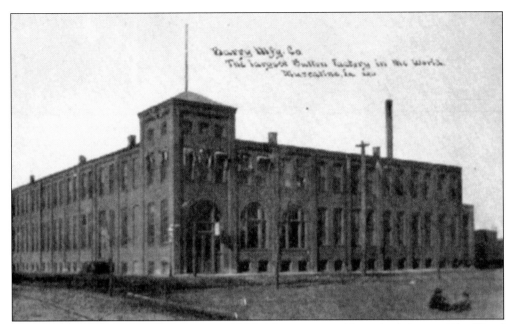

BARRY MANUFACTURING COMPANY, C. 1904. Muscatine would not have become the "Pearl Button Capital of the World" without brothers John and Nicholas Barry. In 1898, they visited a neighboring button shop and became convinced that they could create a more efficient machine. In 1900, their first machine revolutionized the button manufacturing process. (Courtesy of Muscatine History and Industry Center.)

NICHOLAS BARRY SR., C. 1900. Nicholas Barry Sr., an Irish immigrant, established a plumbing business in Muscatine. By the time his sons, Nicholas Jr., Patrick, and Thomas, began experimenting with button making equipment, Nicholas Sr. had retired. (Courtesy of the Barry family.)

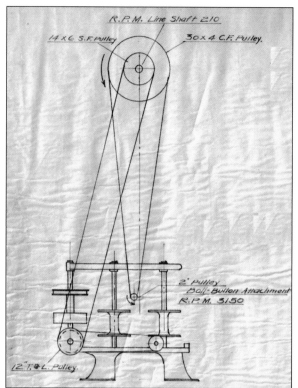

BARRY AUTOMATIC FACING AND DRILLING MACHINE, 1923. Women hand-fed smooth, flat blanks into chucks. As the chuck revolved, blades cut the pattern on the button face while drills formed the holes. A suction pipe lifted the button from the chuck and dropped it into a bucket under the machine. (Courtesy of Alexander Clark House.)

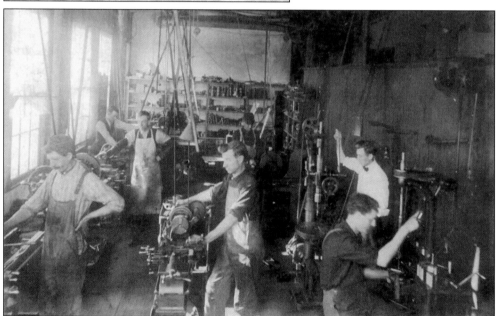

WORKERS AT BARRY MANUFACTURING COMPANY, 1910. The company also expanded into the manufacturing of pulleys and transmission machinery. A plant located on Poplar and Fifth Streets was opened in 1915 to manufacture pulleys. At this time, the firm changed its name to Barry Company and was incorporated for $500,000. (Courtesy of Muscatine History and Industry Center.)

Three

PEARL FEVER

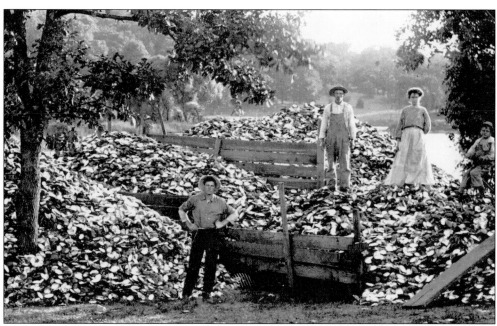

MILLER FAMILY HARVESTING MUSSELS, C. 1915. The pearl button industry employed thousands of mussel fishermen known as clammers. With a minimal start-up cost, the button industry's demand for shell, and the potential to find valuable pearls, clamming became the Mississippi River's gold rush. As mussel beds became depleted, clammers moved to rivers throughout the Midwest. (Courtesy of Nancy Keel.)

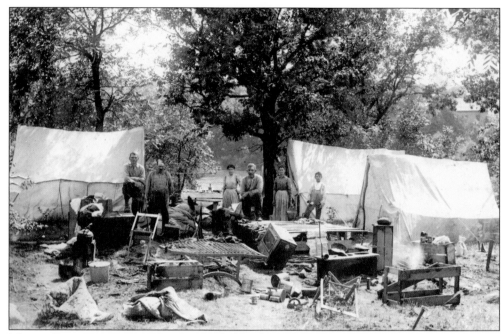

MILLER FAMILY, C. 1915. Clammers and their families set up riverbank camps where several families sometimes formed a village of tents and crude buildings. Men worked the shell beds while women and children steamed the mussels open, separated mussel shells, set up camp, and prepared meals. (Courtesy of Nancy Keel.)

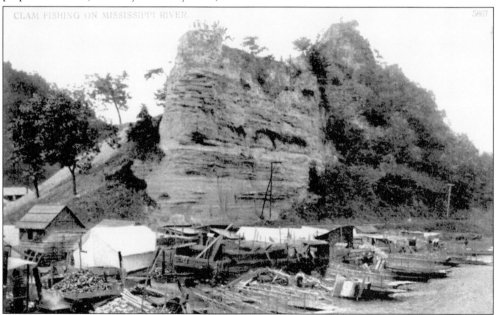

CLAMMING BOATS ON THE MISSISSIPPI RIVER, C. 1905. As early as 1908 and continuing into the 1920s, the clamming industry averaged between 40,000 and 60,000 tons of shell annually at a value of $800,000 to over $1 million. Life on the river was not always peaceful. Clammers fought over mussel beds. One went so far as to mount cannons on his boat. (Courtesy of Muscatine History and Industry Center.)

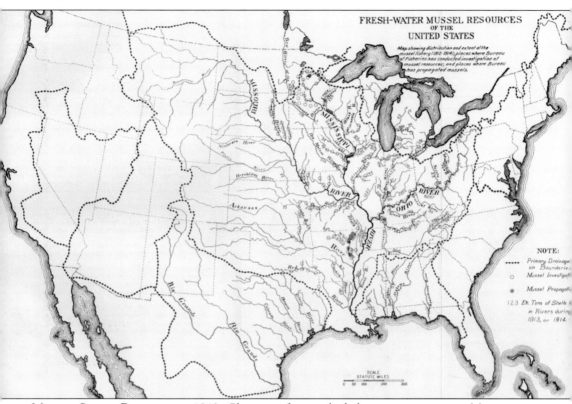

FRESH-WATER MUSSEL RESOURCES
OF THE
UNITED STATES

Map showing distribution and extent of the
mussel fishery (1912-1914); places where Bureau
of Fisheries has conducted investigation of
mussel resources; and places where Bureau
has propagated mussels.

NOTE:
----- Primary Drainage
sin Boundaries
○ Mussel Investigat
● Mussel Propaga
123 Et. Tons of Shells
in Rivers during
1913, or 1914.

SCALE
STATUTE MILES
0 50 100 200 300

MUSSEL STUDY RESULTS, C. 1913. Clammers first worked the waters nearest to Muscatine and eventually spread into 19 states as the industry grew and local mussel beds were depleted. The first warning signs of mussel bed depletion came within a decade of the industry's start. In 1908, Congress established the Fairport Biological Station, located outside of Muscatine, to study mussel propagation. The button manufacturers helped support Fairport's research. Nearly 300 different species of freshwater mussels are native to North America, and 75 species are native to the Midwest. About 10 percent of North American mussels are extinct. Another 210 species are at risk of disappearing. While the pearl button industry commonly used about a dozen species, environmental factors further threaten the mussel's existence. Pollution, silting, and dredging destroy the mussel's habitat. This map was printed in the Bulletin of the Bureau of Fisheries, 1917–1918. (Courtesy of Muscatine History and Industry Center.)

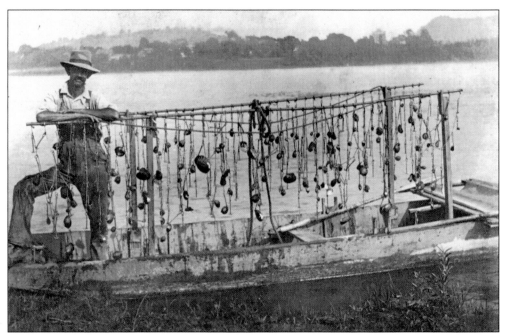

CLAMMER WITH CROWFOOT BAR, 1920. From his boat, the clammer could employ a number of shell collecting methods. The most common method involved the crowfoot bar, consisting of a bar, hooks, line, and rope. Clammers often built their boats at a cost of $10 to $15 in 1914. The engine was the largest expense at over $30. (Courtesy of Muscatine Art Center.)

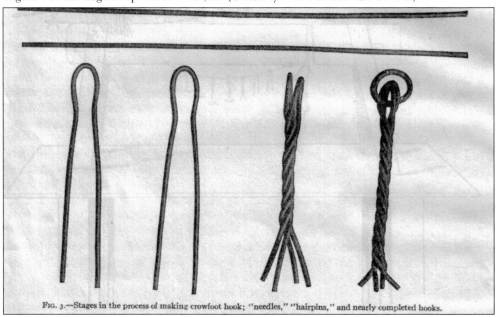

FIG. 3.—Stages in the process of making crowfoot hook; "needles," "hairpins," and nearly completed hooks.

DRAWING OF A CROWFOOT HOOK, C. 1912. The crowfoot played to the mussel's instinct to snap shut when an object entered its opening. Homemade equipment kept down the cost. The only tools needed to turn wire into crowfoot hooks included an iron vise or steel plate with holes drilled through, a pair of pliers, and a small rod for twisting. (Courtesy of Muscatine History and Industry Center.)

MILLER FAMILY GATHERING MUSSELS, C. 1915. In shallow waters, clammers had the option of not using equipment. Clammers used the term "polly wogging" to describe wading in water and searching for mussels with their feet. Sometimes children did this on their own, earning just enough with their mussel harvest to purchase a movie ticket. (Courtesy of Nancy Keel.)

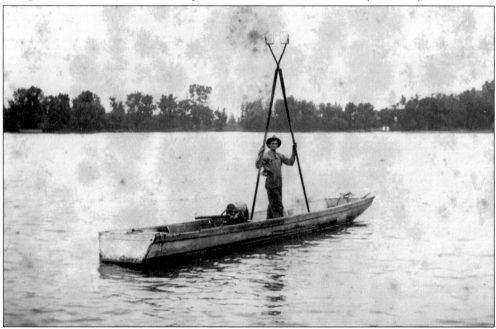

CLAMMER WITH SCISSOR FORKS, C. 1920. Shell tongs, known as scissor forks, were used from an anchored boat. Clammers worked the forks together on the river bottom, closing over mussels. As the forks were raised, the clammer carefully kept the forks closed, raising them hand over hand. The load was then rinsed of excess mud and sand. (Courtesy of Muscatine Art Center.)

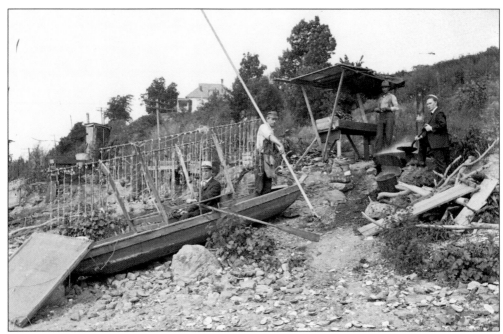

CLAMMERS AND SHELL BUYERS ON MUSCATINE SHORE, C. 1902. The shoulder rake consisted of a rake and wire netting secured to a 15- to 20-foot-long wooden handle. After anchoring the boat, the clammer placed the rake into the river and worked the length of the boat before raising the rake to the surface. (Courtesy of Musser Public Library.)

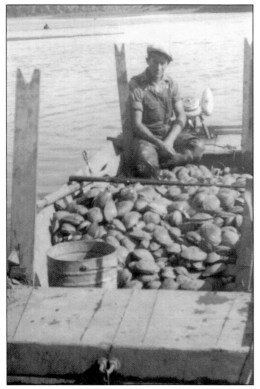

HOWARD MCCLEARY, C. 1948. Not every shell living on the river bottom made a good pearl button. Clammers looked for shell beds with a high percentage of ebony shells, washboards, three ridges, muckets, and pimplebacks. The ebony shell's smooth surface and pearly luster brought an especially high price. (Courtesy of Nellie McCleary.)

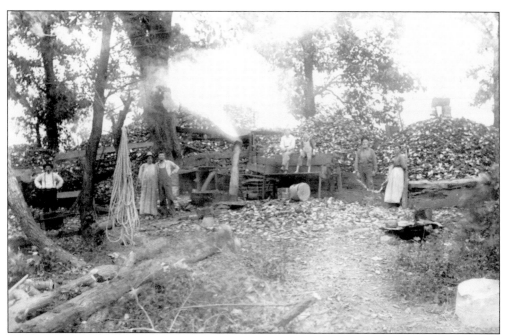

MILLER FAMILY WITH MUSSEL HARVEST, C. 1915. The clammer's work did not end with collecting mussels. The shells were taken to shore where they were placed in a large tank. Water was added, and a fire lit under the mussels. This killed the mussel, allowing the clammer to pull the two halves apart. (Courtesy of Nancy Keel.)

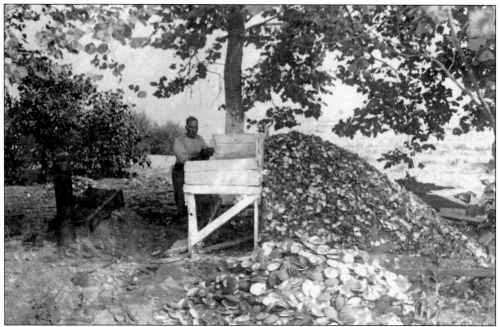

UNIDENTIFIED MAN SORTING SHELL, C. 1920. As clammers separated the two shell halves, they removed the meat of the mussel. This meat was a poor food source for people but was sometimes used as fish bait and animal feed. Often the meat was discarded into the river. Clammers also looked for pearls found inside the shell. (Courtesy of the Muscatine Art Center.)

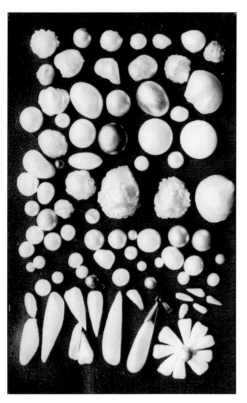

PEARLS AND SLUGS, C. 1915. The demand for shell brought a regular income for the clammer, but a round pearl had the potential to make his financial worries disappear. Clammers frequently found irregular-shaped pearls, called slugs. On average, slugs were found in one out of 100 shells. (Courtesy of Musser Public Library.)

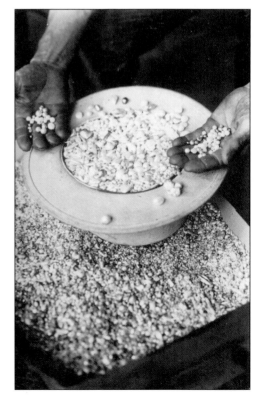

PEARLS AND SLUGS, C. 1915. Shell buyers often purchased pearls and slugs from clammers. Buyers carried small scales and set a price per weight for slugs. The price of round pearls was set through negotiation with the clammer. Clammers were protective of valuable pearls as theft was a legitimate concern. Some buyers were known to trick clammers during their negotiations in taverns. (Courtesy of Muscatine History and Industry Center.)

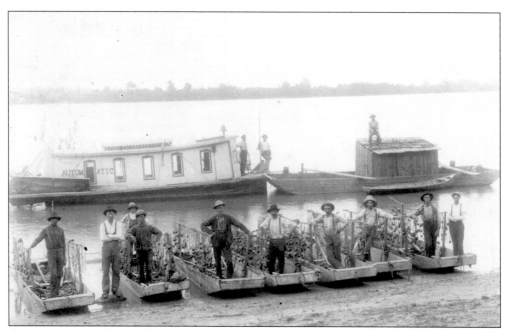

CLAMMERS WITH SHELL BARGE, C. 1910. Some button companies contracted with clammers and operated their own shell barges. Button factories had to plan ahead to maintain a supply of shell through the winter months. (Courtesy of Musser Public Library.)

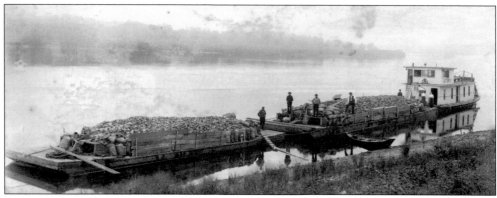

SHELL BARGE, BUTTERFLY, C. 1910. Amateur photographer Arnold Miller of Muscatine captured this image of the *Butterfly*. Miller's work as a shell buyer for McKee Button Company allowed him to document the daily lives of clammers and their families. (Courtesy of Nancy Keel.)

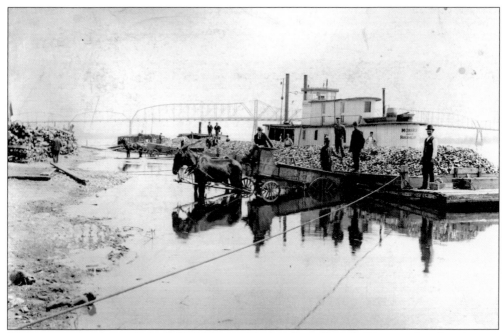

UNLOADING SHELL FROM THE MONARCH, C. 1900. Independent shell buyers also played a part in supplying cutting shops and factories in Muscatine and other communities. Buyers purchased shell by the ton. The average price per ton was $16 in 1914 with the price doubling only a few years later. (Courtesy of Muscatine Art Center.)

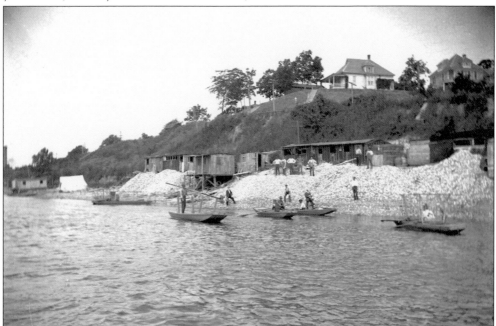

CLAMMING BOATS AND SHELL CUTTING SHOPS, C. 1906. Some shell cutters worked close to the source of their raw material. Men in Muscatine operated cutting machines on the riverbanks. Some took it a step further and set up machines on barges, tossing the leftover shell back into the river. (Courtesy of Musser Public Library.)

RAILROAD CAR WITH SHELL PILE, C. 1920. Charles "Mick" Hagermann remembered having to unload shell: "My first job they gave me in the button factory was unloading rail car with an open coal car of shell. . . . Well you buy the shell by the ton so if they cleaned them up too good, they'd be a lot lighter. So they didn't clean them anymore than they just had to. Well when you get a whole rail car full of those in the summer and you got to get in there with a shell fork and unload them, why it's kind of a messy job. There isn't any worse job than that. I found out that wasn't part of the button business I wanted to be in." (Courtesy of Musser Public Library.)

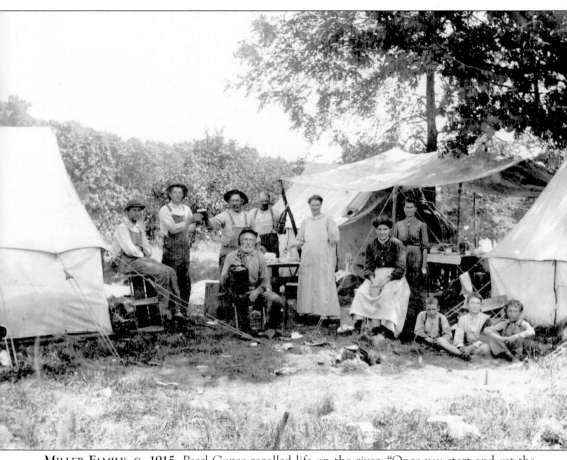

MILLER FAMILY, C. 1915. Pearl Gonse recalled life on the river: "Once you start and get the freedom of outdoor life, you don't want to work in the shop in the summer. One year when we were on the Rock River with another couple, we had a large Army tent that was 16' by 16'. It had a big pole up in the center and it was really nice. We had old linoleum on the floor, we had folding cots and a table and orange crates piled up for a cupboard and an oil stove too. We just loved it out there. It was very pleasant and a lot of fun when there would be several of our friends with us camping. We always made more money shelling but they always let you come back to the shop in the fall because they needed the shells. We hated to come home. We were the last ones to come back." (Courtesy of Nancy Keel.)

Four

BUTTON BOOM

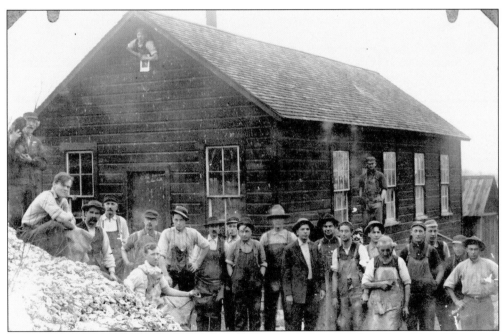

SHELL CUTTING SHOP, C. 1910. Small shell cutting shops popped up throughout Muscatine and other communities. Neighborhoods hummed with the sound of cutting machines. Piles of cut shell accumulated in alleyways. Cutting shops ranged in size from one-man outfits to more sophisticated operations employing several dozen men. (Courtesy of Nancy Keel.)

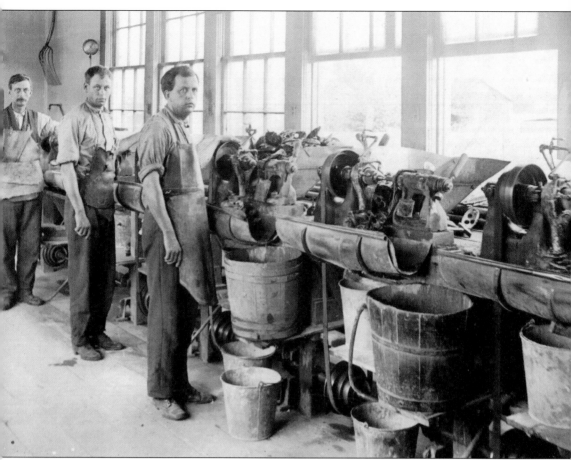

ARTHUR, RAY, AND EDWARD SCHILDBERG, C. 1935. Brothers Arthur, Ray, and Edward Schildberg worked together in a cutting shop located at 616 Maple Avenue in Muscatine. The Schildberg cutting shop operated from 1934 to 1946. Families often went into the shell cutting business together. Clarence Lick of Muscatine recalled his father's cutting shop: "We had thirteen machines, what we called them, behind our residence there. And men came there and worked for us. We in turn worked for Weber & Sons. I remember the big pile of shell behind our place at all times. The shells would be hauled in to us. They hauled them in from the Wabash, I think. They came in different sorts of sizes. My father would have to sort those sizes because different size shells they cut different size buttons out of." (Courtesy of Muscatine History and Industry Center.)

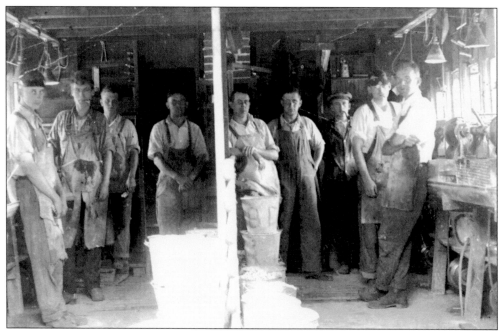

C. SCHMARJE BUTTON WORKS, C. 1930. The cutting shop's crude interior commonly featured a series of machines arranged below a row of windows that provided the major light source. Buckets of shells and button blanks, tongs for holding shells, saw files, and other tools were scattered in work areas while shell dust covered surfaces. (Courtesy of Muscatine History and Industry Center.)

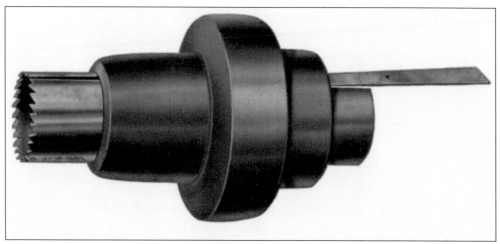

ILLUSTRATION OF A SHELL CUTTING SAW, C. 1915. Shell cutters operated lathes with tubular saws made of hardened steel and used tongs to hold the shell in place. Jets of water sprayed on the saw during cutting to keep it cool and to control dust. The cutter produced "blanks" or circular pieces of shell with one rough side and one smooth side. (Courtesy of Charles and Shirley Hagermann.)

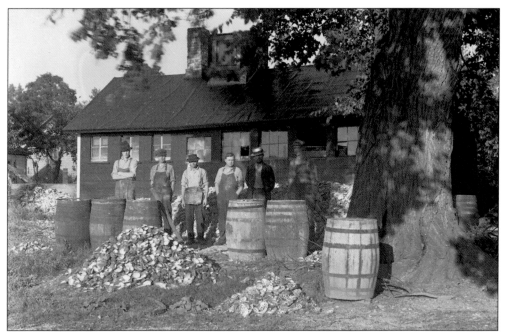

HEINTZ CUTTING SHOP IN ANDALUSIA, ILLINOIS, 1915. Before the shell could be cut, it soaked in water for at least one week. Without proper soaking, the brittle shell splintered and caused extreme wear on cutting saws. Although clammers removed much of the mussel's meat, what remained caused the water to turn especially pungent. (Courtesy of Augustana College.)

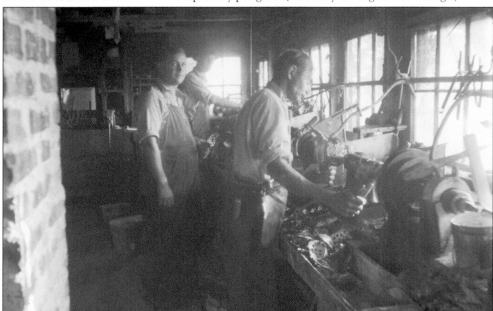

WORKERS AT HEINTZ CUTTING SHOP IN ANDALUSIA, ILLINOIS, 1915. Working conditions in shell cutting shops were unpleasant at best. The water needed during cutting drenched workers with building temperatures fluctuating. All workers experienced the discomfort of standing in the same position all day, but many also sustained injuries. While shell dust irritated the throat and lungs, flying shell particles caused eye injuries. (Courtesy of Augustana College.)

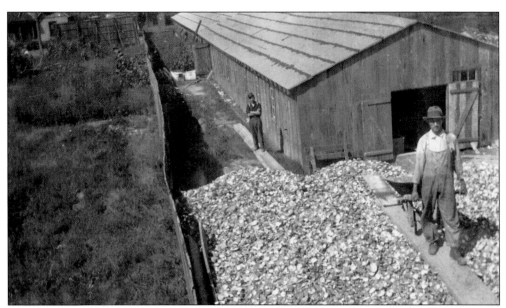

UNIDENTIFIED SHELL CUTTING SHOP, C. 1915. The average cutter could use up to 100 pounds of shell a day, resulting in about 25 gross, or 3,600 blanks. Since workers were paid by the piece, they wanted to produce as many blanks as possible. The cutting shop carefully weighed the amount of shell given to each worker. (Courtesy of Nancy Keel.)

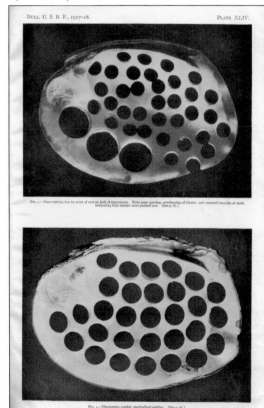

ILLUSTRATION OF CUT SHELLS, 1919.
The skill and careful attention of the cutter was required to obtain the optimal number of blanks per shell. Managers penalized workers for cutting imperfect, thin, and otherwise unusable blanks. Workers were also held responsible for excessive waste of shell. This image, from the Bulletin of the Bureau of Fisheries, compares the work of a good cutter with that of an inexperienced cutter. (Courtesy of Muscatine History and Industry Center.)

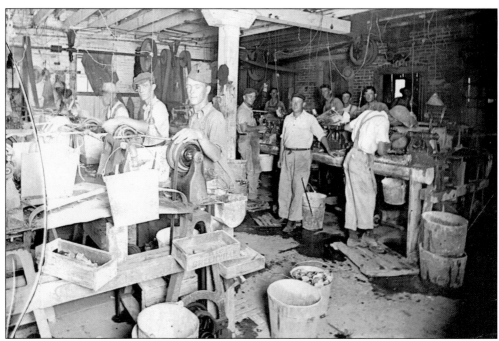

CUTTING ROOM, C. 1920. Workers were expected to equip themselves with tools such as shell tongs, saws, files, hose, and bibs. Managers found that workers were more careful with their own tools, especially shell cutting saws. A good worker would use two saws each week while a careless worker would waste many more. (Courtesy of Muscatine Art Center.)

Week ending *Mar – 21 – 16*

Name *C. Brown*

Test *Mt Tops* Line *18* Lbs *

Count *334* Price *6½* Total *83*
Consisting of 168 Good Blanks Not Transferable
 Non-Negotiable

Weigher *W. A. Nutt*

WAGE SLIP, 1916. Workers were also paid by the size and thickness of their blanks. Buttons were measured by line size. Cutting machines ran more quickly for smaller line sizes and more slowly for larger sizes. Workers cutting large sizes produced fewer blanks but were paid more per piece. Shell thickness was also a factor in the amount of time required to cut the blank. (Courtesy of Muscatine History and Industry Center.)

42

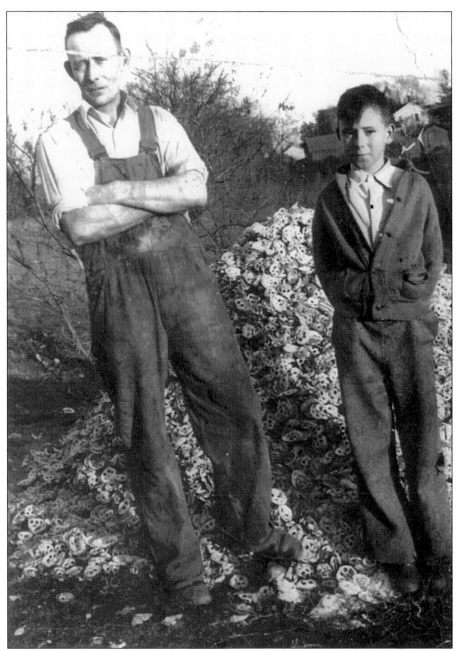

Father and Son with Cut Shell Pile, c. 1940. Boys worked alongside their fathers. Those who were too young to operate a cutting machine were given chores such as filling buckets with uncut shell and emptying buckets of cut shell. Boys often sorted shells according to size prior to the cutting process. Early child-labor regulations did not apply to businesses with eight or fewer employees. Ruth Phillips, daughter of Hawkeye Button Company owner, Frederick C. Vetter, recalled: "The cutting plants became family projects. Anybody who had an old garage or something could get a machine. They'd get the neighbors to come and help, and it became a neighborhood project so that the town was honeycombed with little cutting plants that supported quite a lot of people."(Courtesy of Muscatine History and Industry Center.)

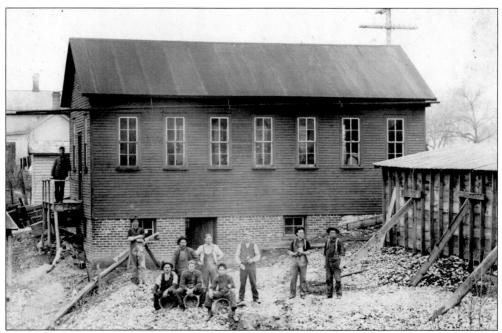

WHEELER AND STORTZ CUTTING SHOP EMPLOYEES, 1906. The Wheeler and Stortz cutting shop opened in Muscatine in 1904 and had closed by 1914. The building was a little more sophisticated than the woodsheds described by some former button cutters but did not compare to larger cutting operations. (Courtesy of Musser Public Library.)

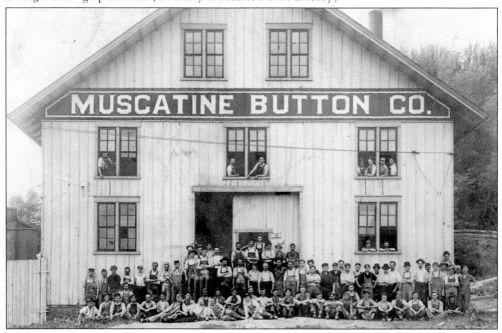

MUSCATINE BUTTON COMPANY, 1910. Little information remains on the Muscatine Button Company, which was located at 913 Mississippi Drive (Front Street). Although the photograph indicates that the company employed over 50 men, it most likely functioned as a cutting shop and did not produce finished buttons. (Courtesy of Musser Public Library.)

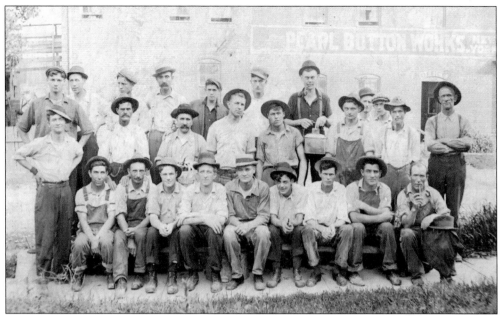

MUSCATINE BRANCH OF PEARL BUTTON WORKS, C. 1900. D. A. Willis of New York City established a cutting plant on the corner of Third and Orange Streets in Muscatine. In 1899, the plant employed over 100 men as shell cutters. The cut blanks were sent to New York to be turned into finished buttons. The factory used 16 to 18 tons of shell each week. (Courtesy of Muscatine History and Industry Center.)

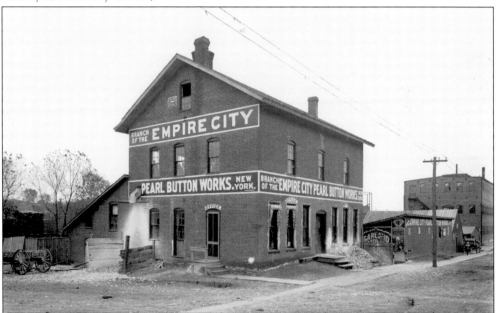

EMPIRE CITY PEARL BUTTON WORKS, C. 1903. The Empire City Pearl Button Works of New York also established a cutting plant in Muscatine. The plant operated at 700 East Fourth Street from 1903 to 1913. As Muscatine grew into the center of the pearl button industry, the trend of cutting blanks in Muscatine and shipping them elsewhere for finishing ended. (Courtesy of Musser Public Library.)

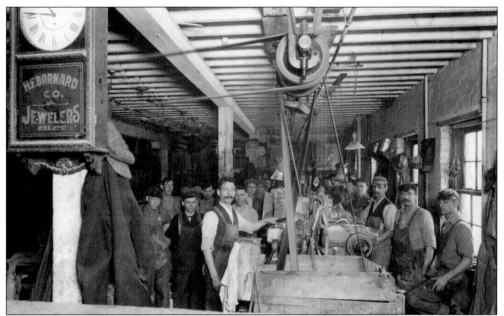

CUTTING ROOM AT U.S. BUTTON COMPANY, C. 1915. Large factories that made finished buttons also included cutting rooms. Although factories had more control over the quality of work within their own cutting rooms, they depended upon smaller shops to supplement their supply of button blanks. Owners of smaller shops in Muscatine hauled their blanks to the factories once a week and were paid by the piece. (Courtesy of Muscatine History and Industry Center.)

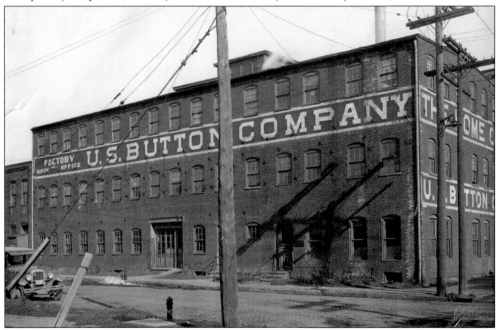

U.S. BUTTON COMPANY, C. 1915. Cutting rooms in large factories were generally located on the building's lower level. Muscatine had nearly one dozen large finishing plants with most employing hundreds of men and women each. Well over 100 small cutting shops also operated within the town. (Courtesy of Muscatine History and Industry Center.)

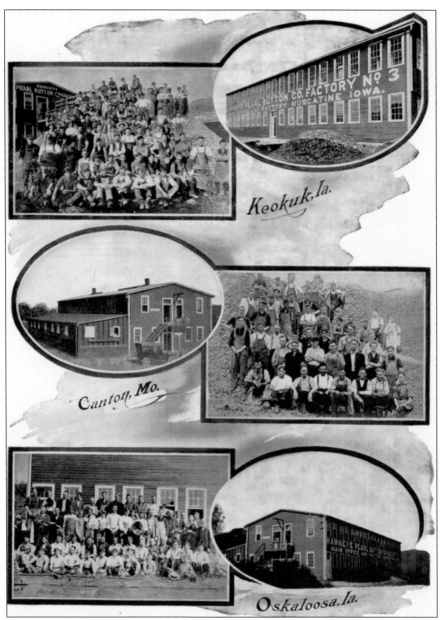

HAWKEYE BUTTON COMPANY CUTTING SHOPS, C. 1918. Some Muscatine finishing plants opened branch cutting shops, often located nearer to active shell beds. Companies found that shipping costs were significantly less for blanks rather than whole shells. Opening cutting shops in other communities had the added benefit of meeting labor demands. Hawkeye Button Company launched cutting shops in Muscatine and other Iowa communities such as Keokuk, Buffalo, Oskaloosa, and Toledo while McKee Button Company started a cutting shop in Keithsburg, Illinois. Most Muscatine finishing plants purchased blanks from cutting shops in other states. Depending on the time period, cutting shops were found from Minnesota to Arkansas. Some shell cutters set up machines on houseboats, allowing them to move from shell bed to shell bed to meet demand while reducing shipping costs. Button manufacturers paid freight charges for shell and blanks in the amount of $131,000 in 1912. (Courtesy of Charles and Shirley Hagermann.)

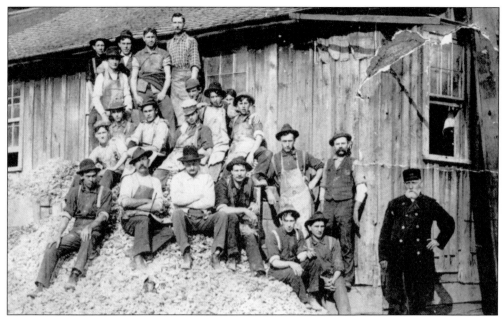

JOSEPH MANTHEY CUTTING SHOP, C. 1902. Muscatine took pride in its claim to fame. The local paper ran an edition titled "Pearls and Prosperity" on December 9, 1899. The paper boasted the number of machines present at each shop and the number of blanks produced on a weekly basis. The Joseph Manthey Cutting Shop was located at 218 Roselawn Avenue in Muscatine. (Courtesy of Muscatine History and Industry Center.)

MEN FROM THE GRAU BUTTON FACTORY, C. 1915. While workers formed friendships with their fellow shell cutters, most men were prepared to leave one cutting shop if better wages or treatment could be obtained elsewhere. The shell cutting business—and the button industry overall—was temperamental due to fluctuations in shell supply, the demand for buttons, and the availability of labor. The Grau Button Factory was located at 1131 Climer Street. (Courtesy of Muscatine History and Industry Center.)

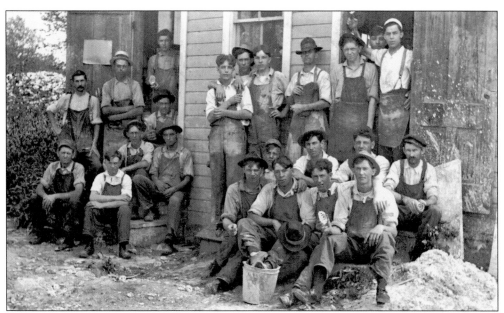

UNIDENTIFIED SHELL CUTTING SHOP, C. 1910. Shell cutters and their employers argued over wages. Workers earned piecework wages, but many owners took a base count and then tabulated it using the weight of the blanks. This imperfect system led to many complaints. In addition, owners sold buttons by the gross, or 144 pieces, but paid workers by the long gross, or 168 pieces. (Courtesy of Muscatine History and Industry Center.)

MUSCATINE JOURNAL ARTICLE, 1900. Less than a decade after John Frederick Boepple's launch of the industry, Muscatine felt the first rumblings of labor disputes in the button business. Nine short strikes occurred in Muscatine's button cutting shops in 1899 and 1900. These strikes did not carry long term implications. The article is from May 1, 1900. (Courtesy of Musser Public Library.)

MANY MEN STRIKE,

Three Button Factories Now Closed Because of Disagreement.

LABORERS ASK FOR BETTER PAY.

Firms Argue Impossibility of More Wages—Interviews With Employers and Employes—No Concerted Action in Matter.

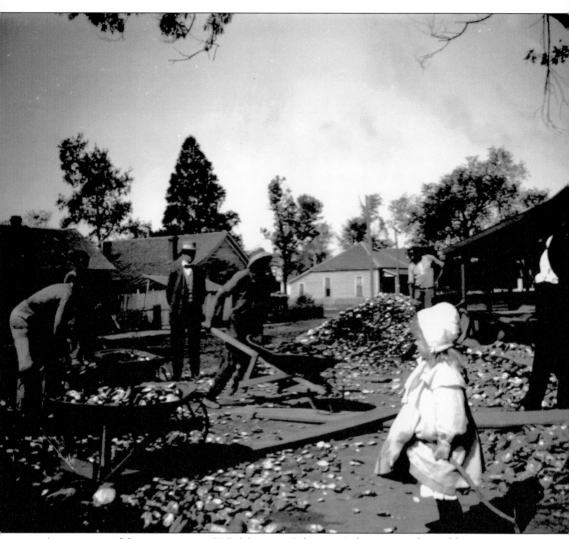

ALLEYWAY IN MUSCATINE, C. 1905. Muscatine's button industry transformed how consumers thought about buttons. Previously the expensive buttons were hoarded and used again and again. The more affordable, freshwater pearl button allowed buttons to be more generally used and almost universally available. The signs of the demand for the freshwater pearl button swept over Muscatine. Edward Mott Woolley, writing for *McClure's Magazine* in 1914, commented, "In all the lanes and byways, and even in the streets, the piles of clamshells littered up the town. . . . Muscatine was button mad." At the time the article was published, Muscatine's button industry had two more years of steady growth before peaking. Shell cutting and button manufacturing continued at a healthy pace into the 1930s. However, Muscatine's involvement with the pearl button did not end until the late 1960s. (Courtesy of Musser Public Library.)

Five

ADVENTURE OF A PEARL BUTTON

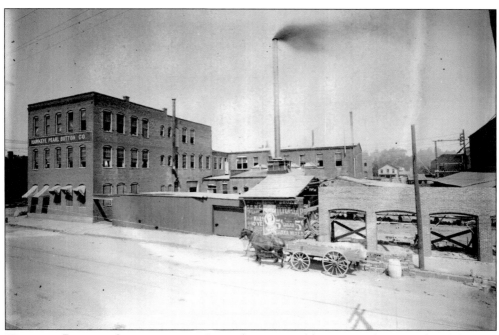

HAWKEYE BUTTON COMPANY, 1917. Large factories, unlike cutting shops, produced finished buttons and were referred to as finishing plants. From shell to finished button, each piece was handled nearly 30 times. Workers completed one step in the process, and most were not considered craftsmen. (Courtesy of Musser Public Library.)

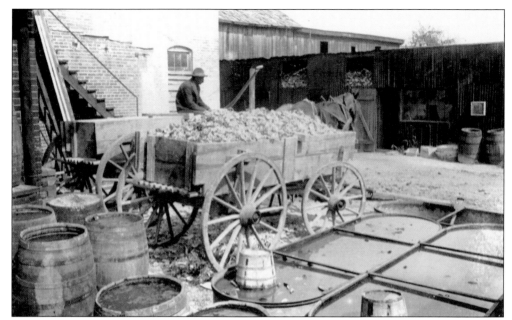

DELIVERING SHELL TO AUTOMATIC BUTTON COMPANY, C. 1905. Although they purchased button blanks from cutting shops, finishing plants generally completed all steps of the button making process, including blank cutting. Areas inside and outside of the factory were dedicated to shell storage and soaking. Space was also set aside for cut shells. (Courtesy of Muscatine History and Industry Center.)

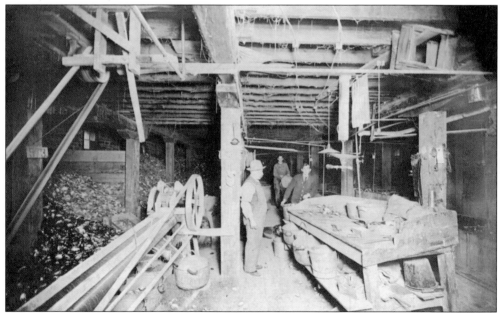

SHELL SORTING ROOM, C. 1905. Men sorted shells by species or quality. Different species of shell were used for different types of buttons. More skilled cutters were given the better quality, and more expensive shell to cut. Factories paid more for ebony shell because of the shell's highly-sought after luster. This image is of the Automatic Button Company. (Courtesy of Muscatine History and Industry Center.)

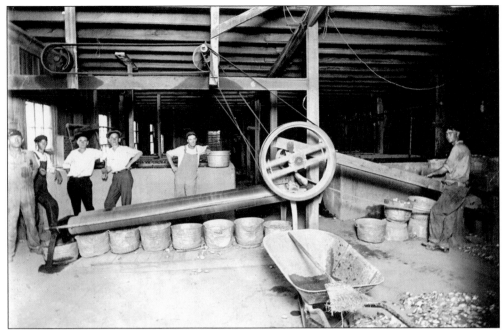

UNIDENTIFIED SHELL SORTING ROOM, C. 1920. Shells were then classified by size. A classifying machine sorted shells by passing them over two hollow metal rollers. The rollers were set at an incline and were not quite parallel to each other. As the rollers revolved, the smaller shells slipped through first, landing into buckets below. (Courtesy of Muscatine Art Center.)

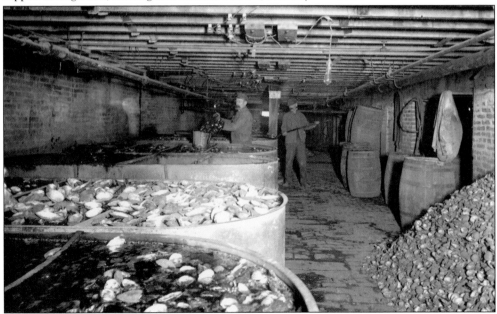

SHELL SOAKING ROOM, C. 1915. Shell soaking rooms were often located in the factory's basement. Men shoveled shell in and out of large troughs where the shell soaked for at least one week. The backbreaking work was not made any easier by the smell permeating the area. Workers could suffer from infections if a cut came into contact with the foul water. This image is of the U.S. Button Company. (Courtesy of Muscatine History and Industry Center.)

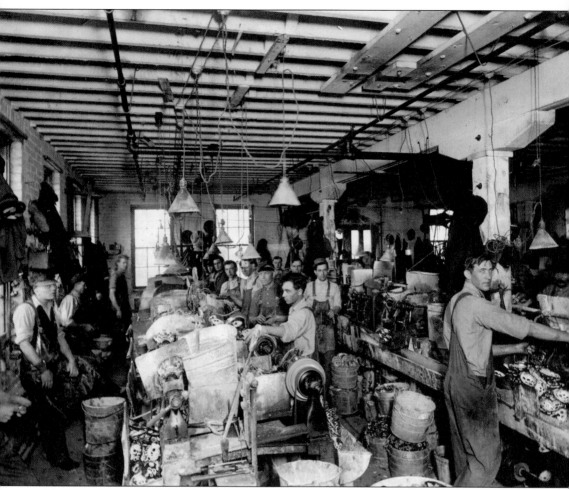

CUTTING ROOM, C. 1915. Having been sorted by species, classified by size, and soaked in water, the shells were ready to cut. Shell cutters inside finishing plants worked on machines similar to those found in smaller shops. Wages were also comparable. Clarence Lick of Muscatine described the cutting process: "Some of [the shells] were easier cutting than others. Some of them were really hard. You had to be careful when you were cutting. When you went to start the saw into the shell, if it slipped sometimes and if you didn't get it started right, then you'd just tear your saw off. And you would have to go back and take your spool out of there and put a new saw in it and put a new set of teeth in it and do the whole thing again. That didn't happen too often. The saw would only last so long. You'd have to stop it and put a new set of teeth on it like you do with a wood saw." This image is from the U.S. Button Company. (Courtesy of Muscatine History and Industry Center.)

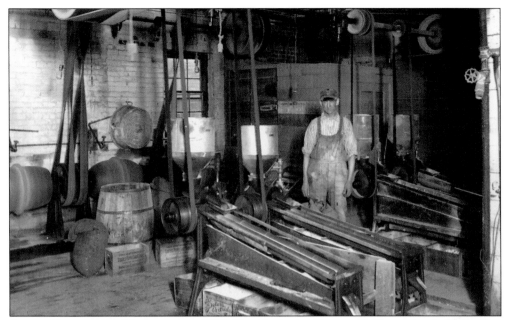

BLANK CLASSIFYING MACHINES, C. 1915. The blank classifier was similar to the shell classifier. The machine consisted of two rollers that sorted blanks by thickness. Different thicknesses of blanks were used to make different types of buttons. Extremely thick blanks made good shank buttons. The machines shown here were from the U.S. Button Company. (Courtesy of Muscatine History and Industry Center.)

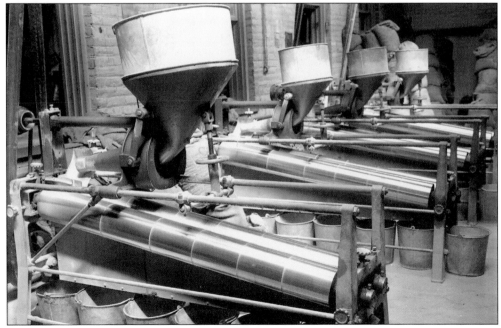

BARRY BLANK CLASSIFYING MACHINE, 1924. Barry Company of Muscatine produced classifying machines as well as many other machines used in button making. This machine had rolls measuring four inches in diameter. The number of blanks classified per minute depended upon the angle of the feeding funnel. (Courtesy of Musser Public Library.)

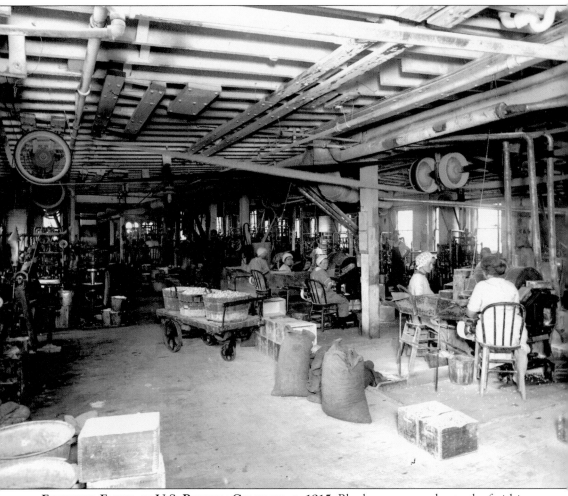

FINISHING FLOOR AT U.S. BUTTON COMPANY, C. 1915. Blanks were moved onto the finishing area where women completed many of the remaining steps. The finishing area featured rows of grinding machines and "Double Automatics," which faced and drilled the button. In some factories, the two types of machines were kept in separate rooms. This photograph shows grinding machines in the near right corner while Double Automatics are found at the back of the room. The line shafts and belts used to power each machine added to the noise of the already loud machines. Factories often kept the dirtier processes of shell soaking and cutting to the lower level while later stages of finishing were designated to another level of the factory. Factories with more than two floors often used the top floors for sorting finished buttons and storing boxed and carded buttons. (Courtesy of Muscatine History and Industry Center.)

**GRINDING MACHINE,
c. 1915.** Once blanks were
classified, the dark exterior
of the shell, known as
the "bark," was removed.
Sometimes the blanks were
churned with water and
pumice stone to remove
the rough edges before
placement in the grinding
machine. This grinding
machine was produced
by Barry Manufacturing
Company. (Courtesy of
Muscatine History and
Industry Center.)

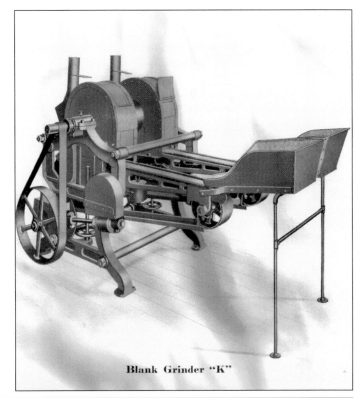

Blank Grinder "K"

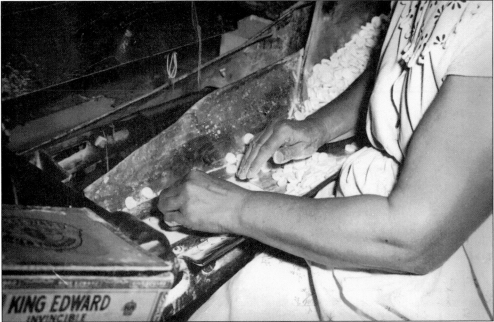

WOMAN WORKING AT GRINDING MACHINE, C. 1950. Women operated machines that removed
bark from the blanks. They placed the blanks face down on moving belts that conveyed the
blanks under large emery wheels. The grinding machine included suction tubes and blowers that
removed excess dust. (Courtesy of Muscatine History and Industry Center.)

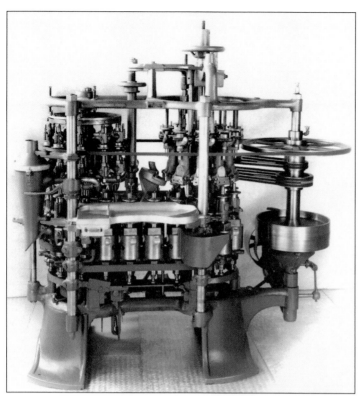

DOUBLE AUTOMATIC MACHINES, C. 1920. The Double Automatic machines were the centerpieces of pearl button manufacturing. The machines performed the functions of carving the design on the face of the button and drilling the holes—two or four—into the button. Workers were responsible for cleaning their machines. Before or after each shift, they removed the chucks to clean out dust. The machine seen here was produced by Barry Manufacturing. (Courtesy of Muscatine History and Industry Center.)

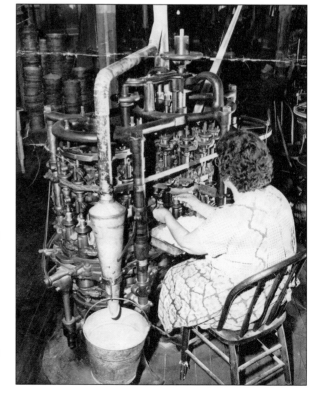

PEARL MOE TERRILL AT DOUBLE AUTOMATIC, C. 1945. Women hand-fed smooth, flat button blanks into Double Automatics. As the chuck revolved, blades cut the pattern on the button face while drills formed the holes. A suction pipe lifted the button from the chuck and dropped it into a bucket under the machine. Pearl Moe Terrill worked at the McKee Button Company. (Courtesy of Muscatine History and Industry Center.)

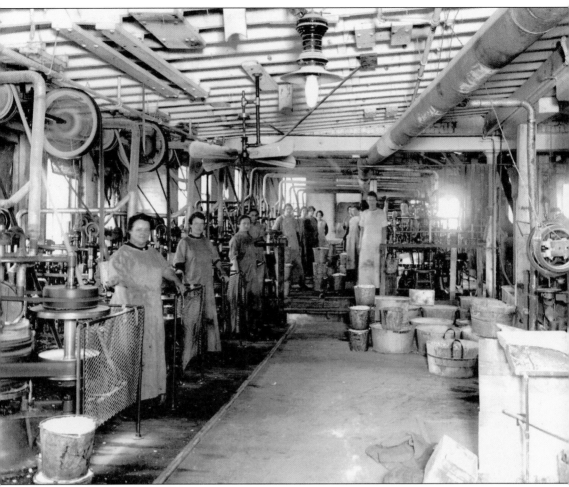

WOMEN AT DOUBLE AUTOMATICS, C. 1915. Each finishing plant contained rows—often dozens—of Double Automatic machines. The work of seven shell cutting machines was needed to supply one Double Automatic, capable of producing over 150 gross or 21,600 buttons each day. Barry Manufacturing supplied these machines to finishing plants throughout the United States. The Barry family, once referred to as "Pioneers of Mass Production," had invented a machine that some compared to the Whitney cotton gin and McCormick reaper. The Double Automatic transformed the button industry by creating a more uniform pearl button that could be produced at one-fourth the cost. The machine helped secure Muscatine's place in history as the Pearl Button Capital of the World. Because Barry made a high quality machine, many of the Double Automatics, after years of making pearl buttons, were adapted for plastic. The women in this photograph are working at the U.S. Button Company. (Courtesy of Muscatine History and Industry Center.)

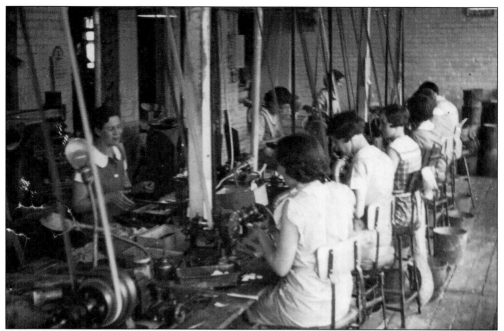

WOMEN IN FANCY DEPARTMENT, 1930S. The Double Automatic quickly turned out simple buttons, but fancier buttons continued to require handwork. Women carved intricate designs by placing individual buttons against emery wheels. These women are working at the Iowa Pearl Button Company. (Courtesy of Muscatine History and Industry Center.)

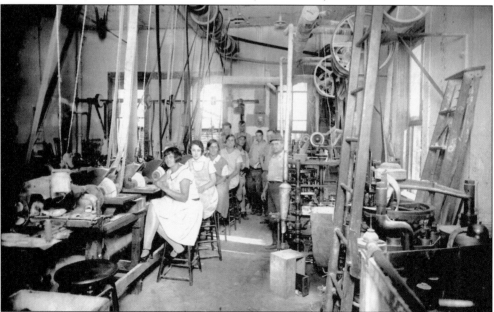

WOMEN IN FANCY DEPARTMENT, 1920S. As with most jobs in button manufacturing, workers in the fancy department were paid by the piece. Although their task was repetitive, the worker needed to pay close attention. Quality was important, but personal safety was an issue with the many line shaft-powered belts running within reach. (Courtesy of Muscatine History and Industry Center.)

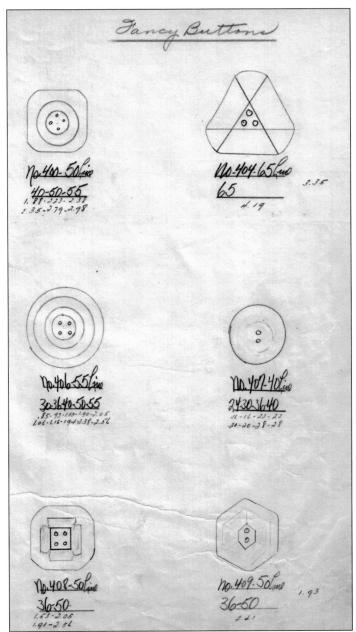

DRAWINGS OF FANCY BUTTONS, C. 1940. To remain competitive in the button business, factories had to produce buttons that met the needs of their customers. Just as clothing manufacturers introduced new lines every season, so did button manufacturers. The person employed to design new fancy buttons was considered a craftsperson and an important asset to the button factory. Because button manufacturers had to quickly provide buyers with their goods, button factories kept their warehouses well stocked. The costs of raw material and labor for fancy buttons were too great to invest in a button that would remain on warehouse shelves. Some designs involved much more than carving fine details by adding rhinestones and metalwork. Fancy buttons were often dyed vibrant colors that suited the fashion of the day. These drawings are from the Muscatine Pearl Works. (Courtesy of Ann Moody.)

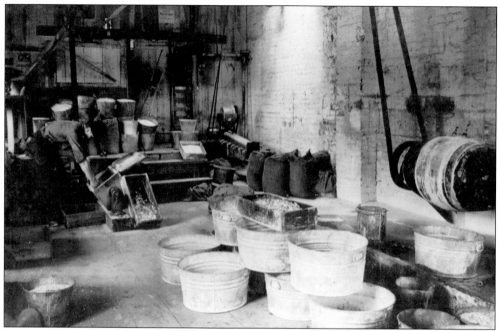

POLISHING ROOM AT AUTOMATIC BUTTON COMPANY, C. 1905. Pearl buttons were not finished until they received a lustrous polish. The first step involved tumbling the buttons with water and pumice. This removed the rough edges and made them ready for their final polish. (Courtesy of Muscatine History and Industry Center.)

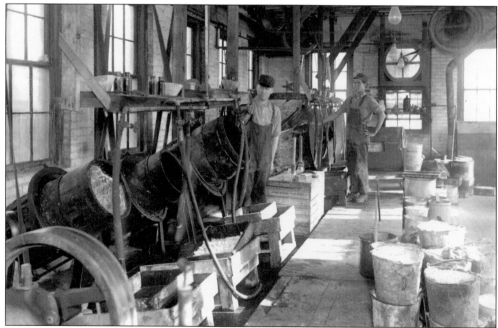

POLISHING ROOM AT U.S. BUTTON COMPANY, C. 1915. Men transferred the buttons to a polishing barrel where the buttons were tumbled again. Steam and sulfuric or other acids aided in giving the button a pearly shine. The polishing process required some specialized knowledge. (Courtesy of Muscatine History and Industry Center.)

ARE YOU ABOUT TO TUMBLE?

THEN you will appreciate the advantages of BARRY'S new line of Tumblers and Polishers. Our Tumblers and Polishers are fitted for either wet or dry tumbling. We give illustrations with dimensions of our newly designed shapes of four sizes, namely: No. 00, No. 1, No. 2 and No. 3. They show the barrel closed, water tight and ready for operation. To empty the barrel it is only necessary to turn the hand wheel, remove the cover and dump the contents. No. 00, No. 1 and No. 2 have cast iron journals, while the No. 3, owing to its large proportions, is fitted with a steel shaft through the barrel.

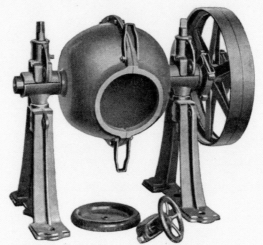

SHOWING BARREL IN POSITION FOR EMPTYING

CATALOG ILLUSTRATION OF TUMBLING BARREL, C. 1920. Barry produced a variety of machines used in button making. In one of its catalogs, the company catches the buyer's attention with the line, "Are You About to Tumble?" and calls attention to the barrel's new design. The tumbling and polishing processes were one of the few steps where it was not necessary to handle blanks or buttons individually. Following the final polish, buttons were dried in shakers containing sawdust or small wooden shoe pegs and washing powder. This step removed excess buildup of polish and gave the buttons their final luster. Sometimes buttons of various sizes were polished together, requiring them to be placed in a separator. Finished buttons were then ready for the sorting department. (Courtesy of Muscatine History and Industry Center.)

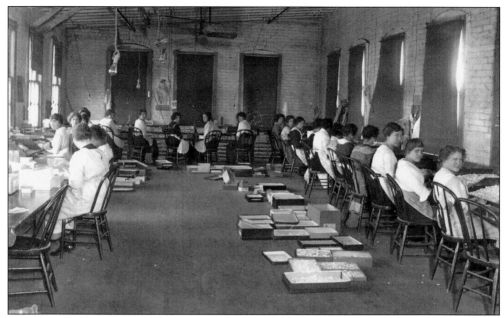

SORTING ROOM AT U.S. BUTTON COMPANY, C. 1915. Girls—often between the ages of 14 and 18—were generally employed for the task of sorting buttons. This tedious task was critical, as factories could not sell mixed buttons. The girls graded the buttons by their manufacturing defects, natural stains, color, luster, and iridescence. (Courtesy of Muscatine History and Industry Center.)

WOMAN SORTING BUTTONS, C. 1950. Proper lighting was essential for the sorter to correctly place the buttons into as many as 15 grades. The buttons were individually handled and thrown into boxes or drawers arranged near the sorter. Some sorters could go through 85 to 200 gross of buttons in a day. In 1914, sorters earned about 1¢ per gross. (Courtesy of Muscatine History and Industry Center.)

DARK GREEN - U-810

Dissolve 2 ounces Brilliant Green Dye and ¼ ounce Bath Control Salt in 1 gallon of water.

Immerse 30 Minute - U-795 Silvered Pearl in this bath when it is at least at 190° F. Temperature should run as close to 200° F. as possible.

Avoid excessive evaporation and maintain the original dye bath volume.

Correct color can be obtained overnight, but longer dyeing will increase evenness and increase yield of usable dyed pearl.

The pearl should be agitated once an hour if dyeing time is short and about once every two to three hours if dyed overnight. Agitation is always more important during the early part of the dyeing period.

When the pearl is removed from the dye bath, it should be immediately rinsed thoroughly in hot water and then dried in sawdust.

Dilution with water to the extent of about 50% will not have any serious effect upon results.

INSTRUCTIONS FOR DYEING BUTTONS, C. 1947. Discolored buttons were often used for dyed or smoked buttons. Men worked as dyers and received extensive training. The Hawkeye Button Company totaled its number of training hours to 3,150. Dyers created standard color choices but also worked with buyers to produce a color button matching their specific instructions. Their extensive training also included handling and storing various chemicals, following recipes for consistent results, and understanding properties of different types of shell. Once dyers became skilled, other button factories in Muscatine actively tried to hire them. Early experiments with bleaching discolored buttons produced limited results. Many factories developed their own specific formulas and methods for dyeing and bleaching. Some dyers were more successful than others in producing colored buttons that would not fade. These instructions are from the Hawkeye Button Company manual. (Courtesy of Muscatine History and Industry Center.)

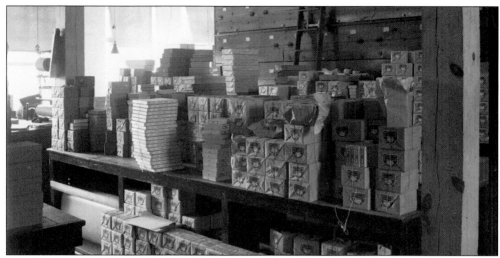

STORAGE ROOM, C. 1905. Clothing manufacturers needed button orders to be filled immediately. The company who had the buttons in stock and at the best prices got the sale. The few weeks needed to make and ship buttons meant that button companies had to anticipate the needs of clothing manufacturers. At the right price, a buyer could be found for most buttons. Velma Brewer recorded her memories of sorting buttons at the Pennant Pearl Button Company: "At one time, I know, when I sorted, everything was sold. . . . They graded them, and a lot of colored buttons was dyed so that they could make good colored buttons out of them. And everything was sold out of that stuff that was half a button. I remember when I was at the Pennant, there'd be a buyer come in that would buy all this, just cash. They put it on, I suppose, cheap garments." (Courtesy of Musser Public Library.)

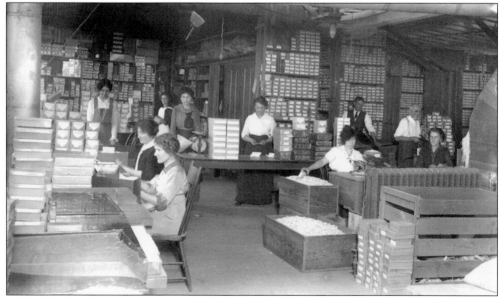

PACKING DEPARTMENT, C. 1905. Companies sold directly to clothing manufacturers who bought buttons by the gross. Rather than hand counting, workers scooped up buttons using a small shovel with 144 holes and placed the counted buttons on a scale. Once the weight was determined, workers could weigh out a gross and box the order. This photograph shows the Automatic Button Company. (Courtesy of Muscatine History and Industry Center.)

BUTTON CARD DISPLAY, C. 1910. Buttons sold in retail shops were sewed to eye-catching cards. Many people, mainly women and children, in Muscatine sewed buttons onto cards as this task could be done from home. Button factories distributed cards, loose buttons, and other supplies to local families and paid them for each complete card. (Courtesy of Muscatine History and Industry Center.)

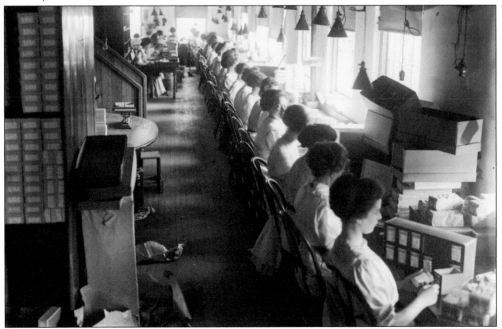

PACKING ROOM, C. 1910. Women also packed buttons at the factory. Retail stores needed attractive boxes to display button cards. Once a good machine for carding or sewing buttons onto cards was developed, women also operated carding machines at the factory. This packing room was in the Hawkeye Button Company. (Courtesy of Musser Public Library.)

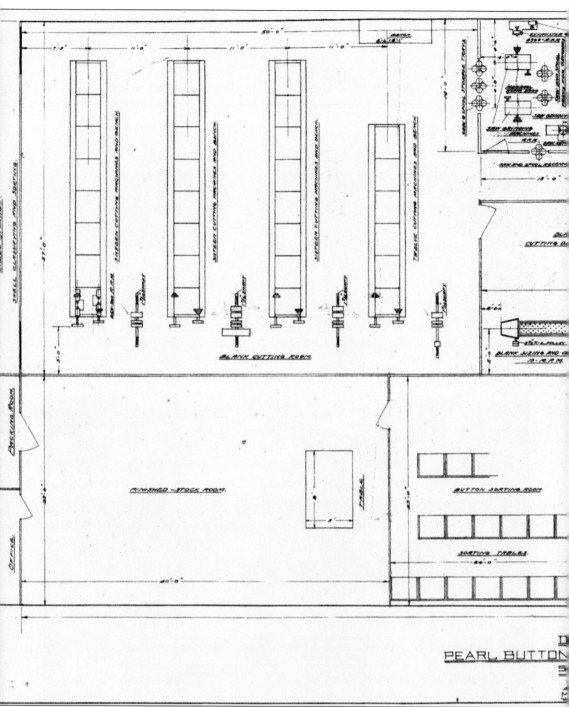

PEARL BUTTON MANUFACTURING PLANT DIAGRAM, C. 1925. Barry Company designed this button factory with efficiency in mind. Each area flowed into the next with each step of the button making process proceeding in chronological order. The layout of the factory required a great deal of planning as all machines operated from line shifts and many machines needed suction and pipes for the removal of shell dust. The operation shown in this diagram would

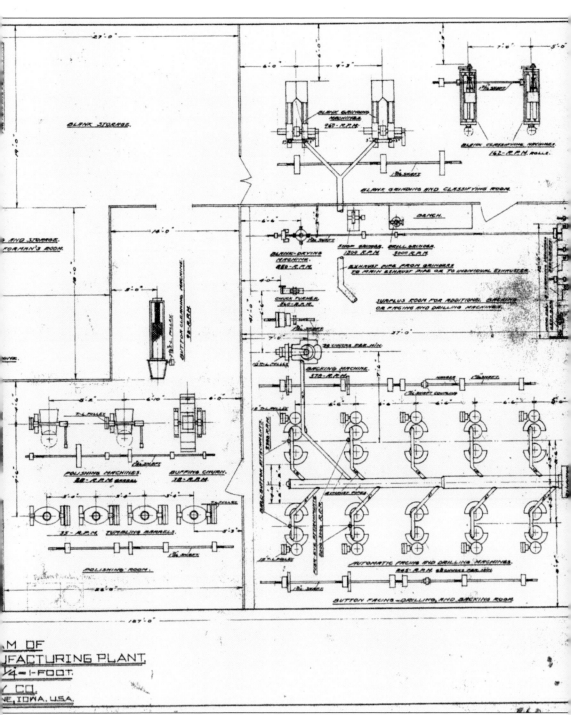

be relatively small compared to other factories. The plan called for only 10 Double Automatic machines, and the entire process from shell storage to the packing room was to take place on a single floor. No evidence remains that this particular plan was ever adopted. (Courtesy of Alexander Clark House.)

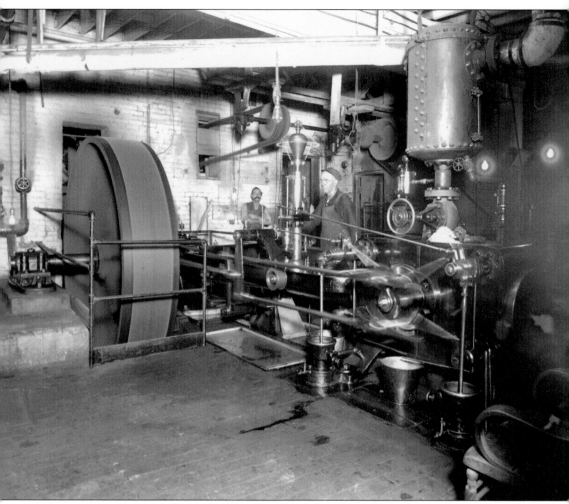

ENGINE ROOM AT U.S. BUTTON COMPANY, C. 1915. The U.S. Button Company relied on a Corliss steam engine to power machines throughout the factory. The engine had valves and two dash pots located on the side of the cylinder chamber. The piston within the cylinder drove the fly wheel. A belt around the fly wheel carried the power into the adjoining room. Rollie Scholten of the Iowa Pearl recalled the steam engine, "Since there was only one engine, rather than numerous small motors as are used today, and this engine had to drive every machine in the plant, there naturally had to be an involved system of shafts and pulleys. Just as long as it was necessary to keep one small machine in the factory running, the big steam engine had to be kept in operation. This whole arrangement seemed wasteful." (Courtesy of Muscatine History and Industry Center.)

Six

A DAY'S WORK

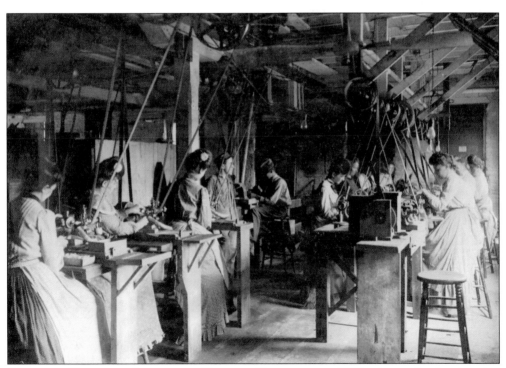

FINISHING ROOM AT AUTOMATIC BUTTON COMPANY, C. 1905. A popular local saying claimed, "No Muscatine resident can enter Heaven without evidence of previous servitude in the button industry." Something as small and ordinary as a button employed nearly half of the area's workforce at the industry's peak. (Courtesy of Muscatine History and Industry Center.)

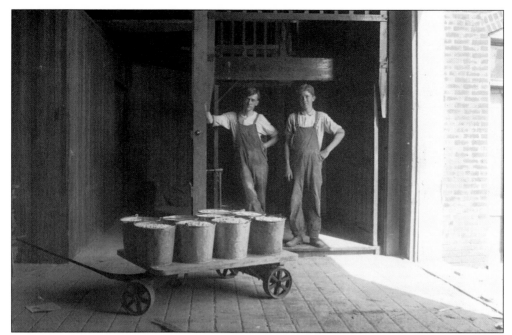

WORKERS AT UNIDENTIFIED BUTTON COMPANY, C. 1905. The 60-hour week of six 10-hour days was standard in the button industry for much of the pearl era. Most cutting shops and button factories operated during the daytime, with only a few major operations running a night shift. (Courtesy of Musser Public Library.)

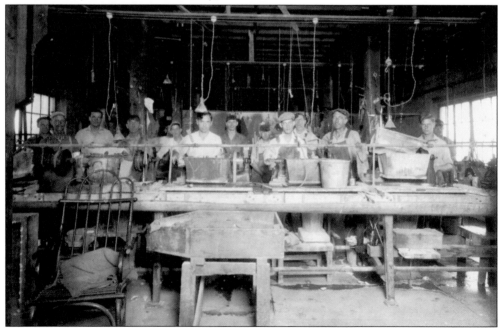

SHELL CUTTERS, C. 1920. Most workers earned piecework wages. Men had more work options available to them than women and could manage factories, serve as foremen, take sales positions, work in the engine room, and dye and polish buttons. The most common job for men was operating a shell cutting machine. (Courtesy of Muscatine History and Industry Center.)

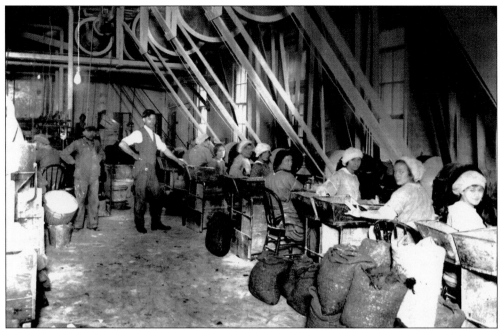

WOMEN AT GRINDING MACHINES, C. 1905. Women often made up the largest percentage of workers in the large finishing plants. Button factories offered young women job opportunities outside of being a household servant, laundress, or department store clerk, for example. (Courtesy of Muscatine Art Center.)

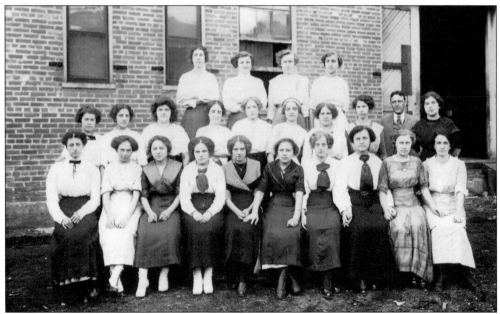

WOMEN OUTSIDE OF HAWKEYE BUTTON COMPANY, 1910. Women worked on grinding machines, ran Double Automatic machines, sorted buttons by size and quality, sewed buttons on cards, packaged buttons, and served in secretarial roles. Women with young children often opted to card buttons from home rather than punching in at the factory. (Courtesy of Muscatine History and Industry Center.)

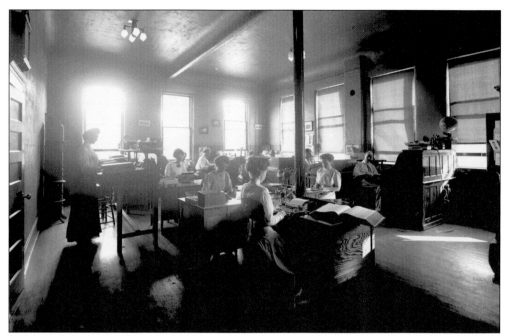

WOMEN IN OFFICE AT HAWKEYE BUTTON COMPANY, C. 1910. Women in the office transcribed sales orders and assisted with payroll. As in many industries, World War II brought about a shift in responsibilities with women stepping into roles previously held by men. Women ventured into the cutting room but also traveled on sales calls. (Courtesy of Musser Public Library.)

IRIS BAUERBACH AT MUSCATINE PEARL WORKS, C. 1940. Iris Bauerbach was one woman who went from completing payroll to traveling to New York City to sell buttons. She remembered, "It was quite an experience for some little farm gal that had never really been out of Muscatine. . . . I always took the train to New York . . . I got to where I thought I was a pretty experienced traveler." (Courtesy of Iris Bauerbach.)

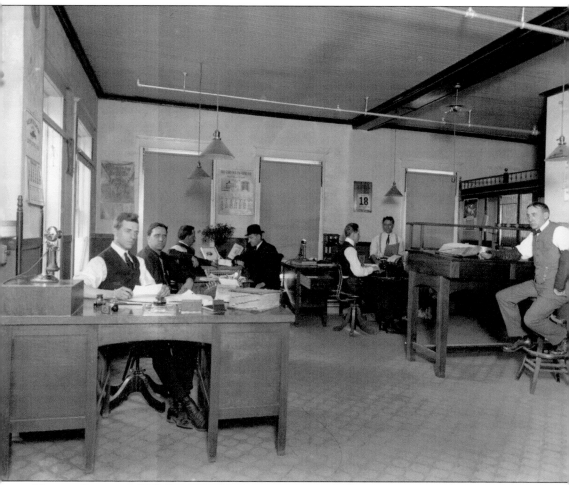

MEN IN OFFICE AT U.S. BUTTON COMPANY, C. 1915. In all positions, except for shell sorters (who could be younger males), men made at least twice the wages of women. Managers earned nearly $35 a week in 1901 and 1902. Clerk was the highest paid position held by women who earned $12 each week in 1901 and 1902. Foremen earned between $12 and $19 while forewomen earned $8. Male bookkeepers, electricians, and shell cutters were within the same earnings ranges as foremen. Female button sorters and carders made up to $6 each week. Women operating Double Automatics could earn an additional $2 weekly. While children worked in the button industry, their earnings were not documented. The entire family, in some cases, was called upon to contribute financially to the household, and the labor-intensive button industry was willing to match just about anyone with an appropriate task. (Courtesy of Muscatine History and Industry Center.)

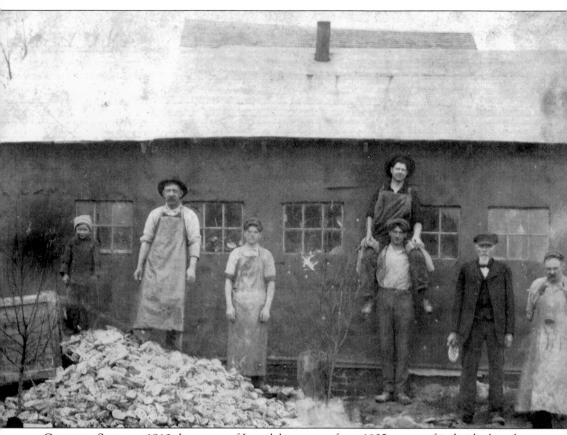

CUTTING SHOP, C. 1910. In a state of Iowa labor report from 1905, wages of individual workers and information about their home lives was collected. The situation of one worker appeared representative of many others employed as shell cutters because he "works ten hours a day, for which he earns $2.00. He has not saved any money over the past year. Supports one person with his earnings. Sanitation is good where he works. Does not indicate enrollment in insurance. Does not own his home. In the past year, his wages have increased 20 cents per day." The situation for another cutter was documented: "Works ten hours per day, for which he earns $1.25. Has earned $360 for the year, with no savings. Supports four people with his earnings. Sanitation is poor where he is employed. Carries $1,000 of life insurance; does not own a home. He has no change in wages over the past year." (Courtesy of Nancy Keel.)

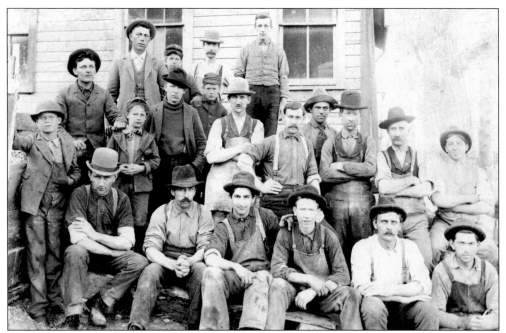

SHELL CUTTERS, C. 1910. Within 10 years of the button industry's launch in Muscatine, the first signs of labor issues erupted. Male shell cutters faced off against cutting shop owners beginning in July 1899. Disagreements centered on wages and costs associated with tools and saws for shell cutting. (Courtesy of Muscatine History and Industry Center.)

MUSCATINE JOURNAL, 1900. Nine short strikes occurred in Muscatine between July 1899 and November 1900. The longest work stoppage lasted 61 days, but most lasted a week or less. All of these strikes were instigated by workers at individual factories, not by the union. This article was from April 30, 1900. (Courtesy of Musser Public Library.)

60 EMPLOYES QUIT.

The Cutters of the New York Factory Walk Out at Noon.

QUESTION ONE OF LOW WAGES.

The Manager, E. A. Willis, Refuses to Treat with Men in Any Manner— Factory Now Closed Down— May Be a Bluff.

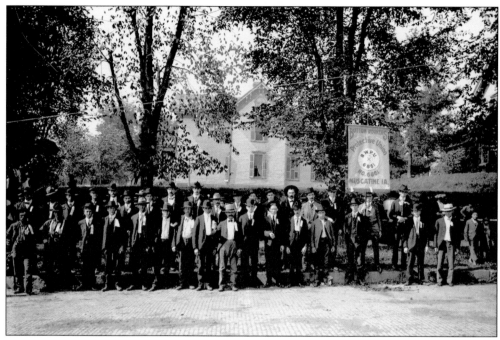

BUTTON WORKERS' PROTECTIVE UNION, C. 1900. Unions in Muscatine in the early 1900s represented a variety of enterprises and trades. The union representing the button workers had a sporadic history. Founded in 1899, the union produced little evidence of its existence after only a few years. (Courtesy of Musser Public Library.)

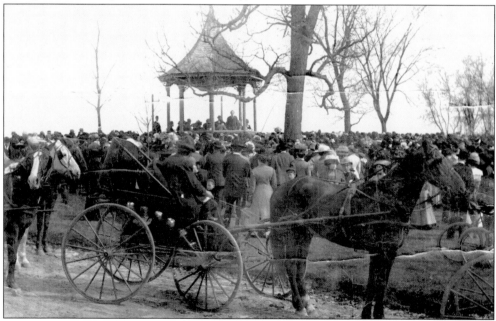

BUTTON WORKERS' MEETING, 1911. By 1910, Muscatine button workers were ready to organize as a powerful force capable of confronting factory owners. Some workers had envisioned a union of 10,000 button workers from throughout the United States. This photograph was taken at Weed Park on April 30, 1911. (Courtesy of Jean Burns.)

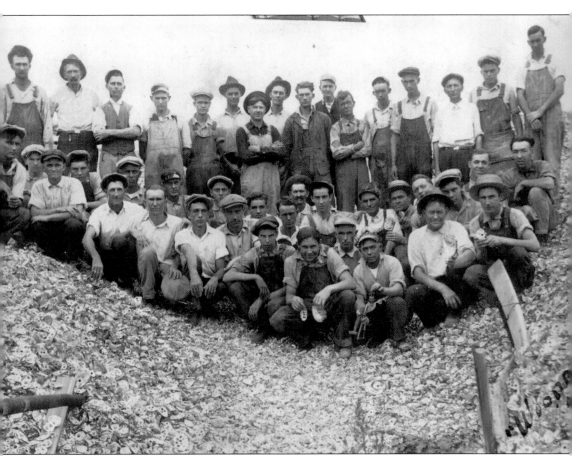

SHELL CUTTERS, C. 1915. Although a national union was not achieved, button workers did establish a protective union associated with the national American Federation of Labor (AFL) on November 9, 1910. Unlike the earlier union, which appears to have involved only male button cutters, women played important roles in organizing and fund-raising for the later union. The union's bylaws stated that the executive board of seven members was to include four men and three women, an auditing committee composed of two men and two women, and a board of trustees consisting of two men and two women. Anyone over 14 years of age working in or about a pearl button factory, including those engaged in carding or other work in the home, could join the union. (Courtesy of Nancy Keel.)

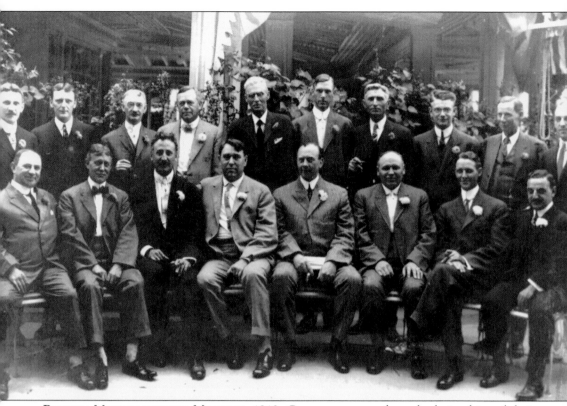

BUTTON MANUFACTURERS MEETING, 1912. Company owners formed relationships of their own. Button manufacturers nationwide regularly met to discuss business. When Muscatine manufacturers announced a shutdown of 43 factories and cutting shops on February 25, 1911, the union saw this as a lockout to scare its members. Button company owners sited overproduction and lessening demand as their reasons behind the closure. The day after the shutdown, 800 union members met and, by March 1, had organized picket lines outside of closed factories. Many businesses and families in Muscatine were sympathetic towards the workers. Businesses made financial contributions while families opened their homes to young women who had lost their livelihood due to the lockout. The following weeks brought failed negotiations, increased frustrations, and growing union membership up to 2,300 people. Some factories reopened despite an official union statement that, "manufacturers in opening their plants, did so without the sanction of the union, and that until a settlement was reached between the two forces, that the members will not return to work." This photograph was taken in Atlantic City, New Jersey, in August 1912. (Courtesy of Muscatine History and Industry Center.)

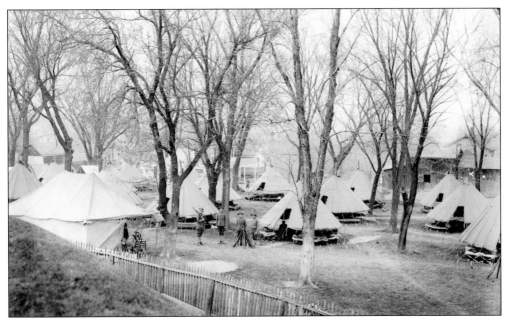

MILITARY ENCAMPMENT IN MUSCATINE, 1911. Picketers and non-union workers engaged in skirmishes. By April 1911, the Muscatine police had hired men from Chicago and St. Louis to help maintain order. Violence increased, and three companies of state militia were called to Muscatine. The town remained under martial law for four days. (Courtesy of Musser Public Library.)

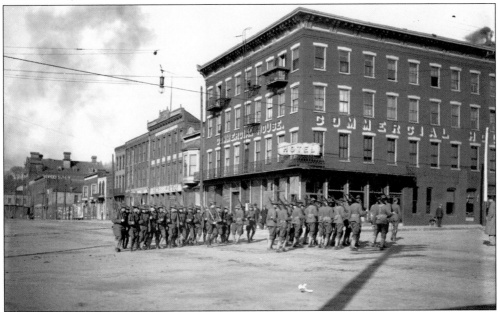

ARMED MILITIA IN DOWNTOWN MUSCATINE, 1911. While the state militia cleared the streets of Muscatine and enforced curfews, Gov. Beryl Franklin Carroll worked with button manufacturers and union representatives to bring about a peaceful resolution. At the end of May, the parties signed an agreement that all former employees would be re-instated with no discrimination against those belonging to the union. (Courtesy of Musser Public Library.)

After MONDAY We Demand the UNION SHOP

MEMBERS ATTENTION!

A mass meeting of all members of the Button Workers' Union is called to meet at ARMORY HALL THURSDAY EVENING, SEPT. 28th, 1911.

Matter of submitting a union shop agreement, voting on a general strike to enforce it, and the matter of A. F. of L. strike benefits must considered.

Forget the carnival. It has indigestion anyway. Come to this meeting. It is of paramount importance. All real members of the Button Workers' Union will be present. The chaff must be sifted from the wheat; the hour of action has come. STAND UP AND BE COUNTED.

Free dance following meeting.

FLIER FOR BUTTON WORKERS' UNION MEETING, 1911. For three months, workers returned to the factories, but regularly alleged that active union members were discriminated against and discharged. Union members wanted manufacturers to recognize their right to organize. After a union worker was fired, the group launched a general strike. (Courtesy of Muscatine Art Center.)

WHAT THE BUTTON WORKERS WANT

October 10, 1911

1--We want to preserve and strengthen our only means of protection against the men who have taken our labor and energies without just compensation, who have poisoned and injured us by failing to provide sanitary working conditions, and who now seek to destroy and injure our good name and fame in this community. We shall and will preserve our "union."

2--We want honest weights, counts and measures, honorable, fair treatment and methods of pay.

3--We want sanitary, comfortable working conditions.

4--We want prompt pay for services rendered and no discounts.

5--We want prompt arbitration of all grievances which may hereafter arise.

6--We want some pay for every button made by us which has a market value.

7--We want the pay doubled for each and every kind of work done in the manufacture of pearl buttons.

8--We want every law-abiding and right-minded resident of Muscatine to join us in our battle for a better "social order" and more "permanent prosperity" for Muscatine.

LIST OF UNION DEMANDS, 1911. By October 1911, the union had published a list of grievances and demands. Some of their demands stretched beyond those outlined in Gov. Beryl Franklin Carroll's agreement. The original agreement had included regulation of piecework wages and fair counting and weighing practices. (Courtesy of Muscatine History and Industry Center.)

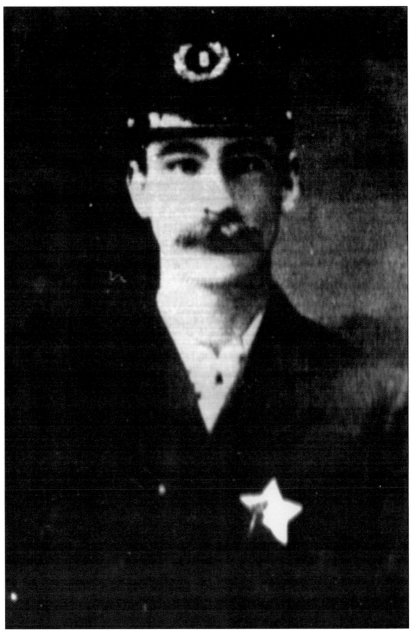

OFFICER THEODORE GERISCHER, C. 1910. Strike-related activities escalated to tragedy in late November 1911 when Muscatine police officer Theodore Gerischer was shot and killed. The *Muscatine Journal* reported: "The fatal shooting occurred on West Third street near Spruce Street, when Officer Gerischer after following a party of youths, who were disturbing the quiet, halted them. Thomas Hoskinson, a member of the group, broke away from the officer and started to run west on Third. Gerischer fired into the air to stop the fleeing man, and Hoskins [sic] stopped and ran up toward him. A moment later another shot was fired and the officer was seen to fall to the walk and Hoskinson ran down to Spruce Street and then turned south and disappeared." When the persons involved with the shooting were stopped and searched, they were found to be in possession of union cards. (Courtesy of Muscatine Police Department.)

THE LABOR WAR
OF MUSCATINE, IOWA

Being a Story of the
Strike of the Button Workers

BY
OLIVER C. WILSON

PRICE, 25 CENTS

LABOR WAR OF MUSCATINE, 1911. Although union workers continued to strike as 1912 began, a number of changes indicated that the strike was winding down. Larger factories began hiring more workers and smaller cutting shops started to reopen. On May 22, 1912, the executive committee of the Button Workers' Protective Union declared, "Inasmuch as the present prospects for a complete victory are not bright, and that the maintenance of the Union is of prime importance, the struggling Button Workers should not be required to make further, and at present, unnecessary and fruitless sacrifices; therefore it is the opinion of the Executive Committee of the Union that Button Workers still on strike can seek employment in the Button Factories without in any manner, violating their obligation to the Union, their pledged faith to their fellow unionists, or their own self respect." Despite the strike's explosive nature, it ended without clear winners. (Courtesy of Muscatine History and Industry Center.)

OLIVER WILSON, C. 1910. Some of the key leaders in the strike were known Socialists. Oliver Wilson, one of Muscatine's Socialist aldermen, held a leadership position in the Button Workers' Protective Union. During the 1911 city election, 65 percent of the button workers voted the Socialist ticket. (Courtesy of Muscatine History and Industry Center.)

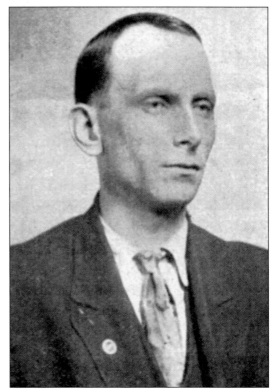

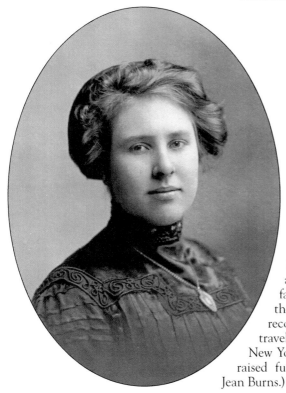

PEARL McGILL, C. 1911. Pearl McGill, an Iowa farm girl working in a button factory, served on the executive board of the Muscatine union and held the office of recording secretary. At the age of 16, McGill traveled to major cities such as Chicago, New York, and Boston where her fiery speeches raised funds for striking workers. (Courtesy of Jean Burns.)

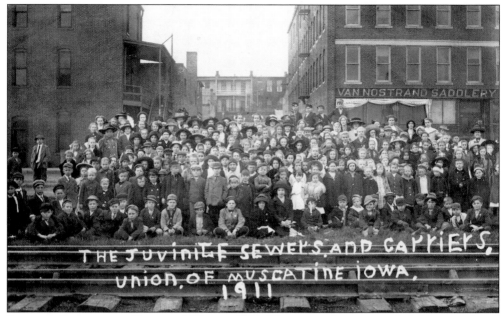

JUVENILE SEWERS AND CARRIERS' UNION, 1911. The union also organized children employed by button factories. Iowa, like other states, struggled with child labor issues. In 1906, Iowa began to regulate the employment of children under the age of 14. Due to the law's limited effectiveness, children continued to work in many industries. (Courtesy of Muscatine History and Industry Center.)

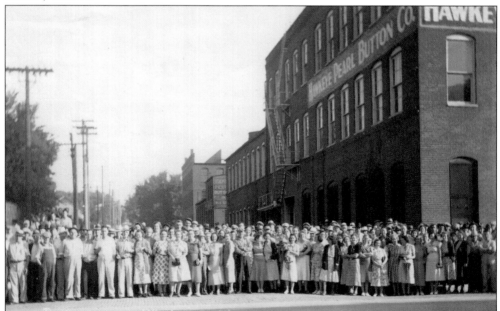

WORKERS AT HAWKEYE BUTTON COMPANY, 1939. The bitterness of the 1911 strike stayed with Muscatine residents for years to come. As the strike in Muscatine wound down, labor unrest continued throughout the United States. Many button workers remained union members, but the only strike to occur later was confined to a single factory. (Courtesy of Muscatine History and Industry Center.)

Seven

BUTTONING THE GLOBE

U.S. BUTTON COMPANY CARD, 1920S.
Muscatine reigned as the "Pearl Button Capital
of the World." Although the 1911 strike
disrupted the button business and everyday life
in Muscatine, the town continued to produce
pearl buttons. The industry itself peaked in 1916
and continued through the 1960s. (Courtesy of
Muscatine History and Industry Center.)

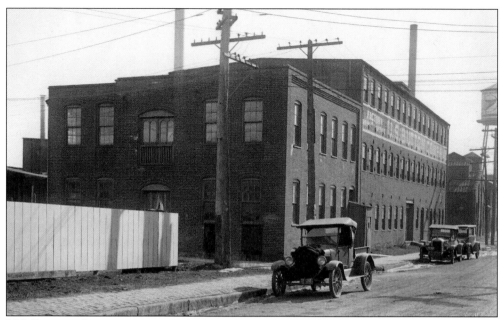

U.S. BUTTON COMPANY, C. 1915. The U.S. Button Company began in 1913 after Muscatine's labor dispute. Edward Hagerman, Archie Adams, Charlie Adams, and Elmer Steinmetz were partners in the business. The factory had served another well-known manufacturer, the Boepple Button Company, which later changed its name to the Pioneer Button Company. U.S. Button Company operated at this location until 1941. (Courtesy of Muscatine History and Industry Center.)

STAMP DEVELOPED BY U.S. BUTTON COMPANY, 1920S. With so many factories competing for their share in the button market, companies searched for new ways to set themselves apart. The story behind this unusual stamp has not survived. (Courtesy of Muscatine History and Industry Center.)

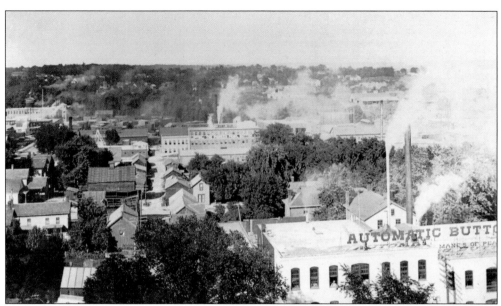

AUTOMATIC BUTTON COMPANY, C. 1905. The Automatic Button Company played a critical part in the button industry's rapid expansion in Muscatine. The Barry family operated their business here before selling the building in 1903 to Henry Umlandt, who housed his Automatic Button Company there. Umlandt and his former partner, John Weber, were the button manufacturers who originally inspired the Barry brothers to invent button making machines. (Courtesy of Muscatine Art Center.)

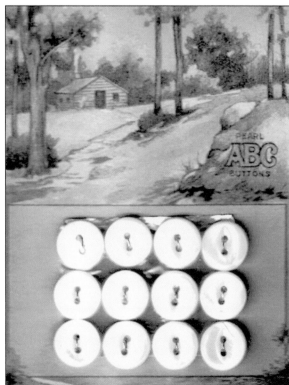

BUTTON CARD, C. 1920S. The Automatic Button Company sold their carded buttons under the brand names of ABC and Blue Bonnet. By 1911, the factory employed 500 workers and manufactured 7,000 gross of buttons each day. The Automatic Button Company operated until 1967. (Courtesy of Muscatine History and Industry Center.)

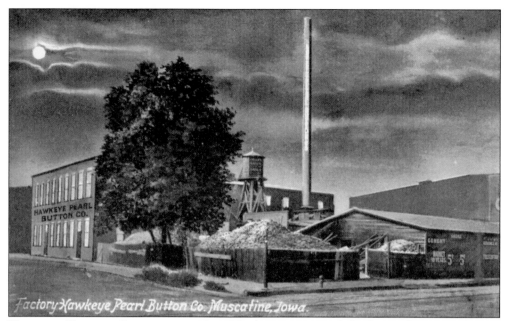

HAWKEYE BUTTON COMPANY, C. 1910. Hawkeye was one of the largest button makers in the United States with satellite cutting shops operating in several communities in and out of Iowa. Frederick C. Vetter, William Bishop, Charles Hagermann, and George Jackson launched the company in 1903. The company had the capacity to employ nearly 1,000 workers by 1920. (Courtesy of Muscatine History and Industry Center.)

CHARLES HAGERMANN AND MARTHA OBERHAUS, C. 1950. Hagermann began his button making career working for industry founder John Frederick Boepple. Hagermann bought the Hawkeye Button Company in 1941 following the death of Vetter, his business partner. The company manufactured both pearl and plastic buttons in the 1950s and 1960s, and closed in 1965. (Courtesy of Charles and Shirley Hagermann.)

MERMAID BUTTON CARD, C. 1915.
Hawkeye Button Company marketed
buttons under the brand names Mermaid
and the Hawkeye Line. Their artistic cards
featured everything from mermaids to
lambs and men in dress shirts to young
women wearing fancy dresses. The company
also manufactured buckles and hat pins.
(Courtesy of Muscatine History and
Industry Center.)

Fresh Water Pearl Buttons
14 to 45 line. 2 and 4 hole
Plain and Fancy—White and colors
Put up on cards of 1, 2, 3 or 12 dozen to card
or loose in boxes or bags of 5 or 10 gross.

We solicit your patronage and assure you
careful attention will be paid to all details.
Samples submitted upon request.

Hawkeye Pearl Button Export Co.
Muscatine, Iowa, U. S. A.
New York Office and Stock Rooms, 930 Broadway
Cable Address: "Hawkeye," Muscatine

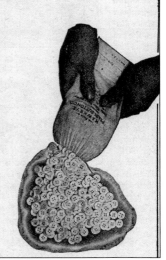

HAWKEYE BUTTON COMPANY ADVERTISEMENT, C. 1920S. Hawkeye maintained offices and
stock rooms in New York City, St. Louis, and Los Angeles. Charles Hagermann's grandson
closed the New York office in 1963. Hawkeye Button Company had been the building's first
tenant. (Courtesy of Muscatine History and Industry Center.)

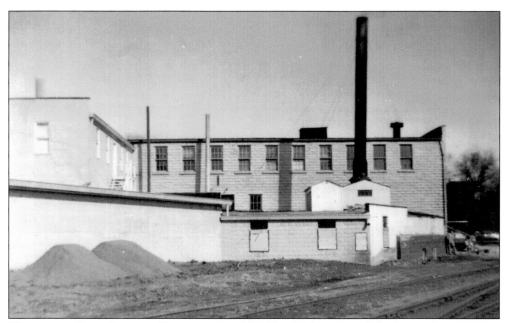

WEBER AND SONS BUTTON COMPANY, C. 1940. The Webers turned the button business into a true family enterprise. John Weber Sr. was born in 1866 in Vienna, Austria, and started the Weber Button Company in Muscatine in 1904. His sons, John Jr., Charles, Walter, Edward, William, Frank, Leonard, and Louis, began working in the family business at the age of 12. (Courtesy of Weber and Sons Button Company.)

AMERICAN MAID BUTTON CARD, C. 1915. By 1914, the company had outgrown its original location on Leroy Street and moved to East Sixth Street. Although the company converted to plastic in the 1950s, Weber's descendents continue to manufacture buttons at this location. (Courtesy of Weber and Sons Button Company.)

Carl H. Schwandke, 1908. The *Muscatine Journal* described the Weber and Sons button factory in 1915: "A visitor to the factory will not immediately discover the Boss. The visitor will note the cozy little business office where C. H. Schwandke, the business and sales manager holds sway, with its desks and stenographers and on a tour of the factory itself he will see and hear the busy, whirring machines with their operatives laden with the fine white dust from grinding of the shells. But he will not have seen anyone who bears even a remote resemblance to what a Boss should look like. Then Mr. Schwandke calls, 'Oh, John,' and through the white dust, himself covered with it, and with hands whitewashed by the deposits, appears a man of medium stature who looks just like any of the other employees except perhaps that he will wear a cap and a dust covered coat. And that is John Weber. He works among his employees, instructing here, adjusting a machine there, and all the time getting down to real hard labor just the same as any other operative." (Courtesy of John and Darlene Schwandke.)

COVER OF MUSCATINE PEARL WORKS CATALOG, C. 1960. Orlando A. Hammer owned the Muscatine Pearl Works, which opened in 1938. Hammer's son-in-law Dick Hines later became company president. The factory was located at the corner of Second Street and Pine Street. (Courtesy of Muscatine History and Industry Center.)

LUCKYDAY BUTTON CARD, C. 1940. The Muscatine Pearl Works marketed carded buttons under the brand name of Luckyday. After a fire destroyed its building on Second Street, the Muscatine Pearl Works rebuilt at a location south of Muscatine. (Courtesy of Muscatine History and Industry Center.)

BLUEBIRD BUTTON CARD, C. 1920.
W. F. Bishop, J. C. Bishop, and F. W. Hermann launched the Iowa Pearl Button Company in 1916. The factory was located at 314 West Mississippi Drive (formerly Front Street). Orlando A. Hammer served as the company's vice president before beginning the Muscatine Pearl Works. (Courtesy of Muscatine History and Industry Center.)

WOMEN FROM IOWA PEARL BUTTON COMPANY, C. 1940. The Iowa Pearl Button Company began small with only 10 Barry Double Automatic machines. As it grew, about 38 machines were operated to meet the demand. The company carded 70 percent of its buttons and sold under the Bluebird trademark. (Courtesy of Muscatine History and Industry Center.)

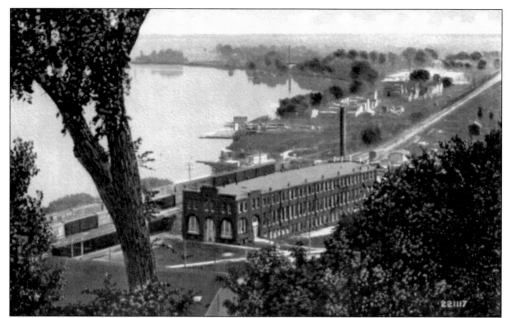

MCKEE BUTTON COMPANY, C. 1920. James McKee and his brother-in-law William Bliven went into the button business together in 1895 when they established the Peerless Button Company. The company changed its name to McKee and Bliven Button Company in 1897 and established the factory at 1000 Hershey Avenue in 1907. Since 1925, it has operated as the McKee Button Company. (Courtesy of Muscatine History and Industry Center.)

MCKEE BUTTON BOX, 1940s. Ted McKee, a third generation button maker, recalled his first job in the button business: "My earliest recollection of work was as a little boy in the late 1930s making wooden boxes to ship pearl buttons." He later served as CEO of the company. (Courtesy of Muscatine History and Industry Center.)

BATTERSON WESSELS ADVERTISEMENT, c. 1915. Some companies served primarily as jobbers for the button business. Batterson Wessels of Muscatine carded buttons and supplied clothing manufacturers. The company maintained a warehouse in Chicago. (Courtesy of Muscatine History and Industry Center.)

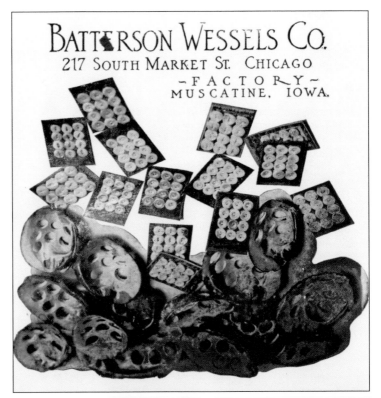

BATTERSON STORE IN MUSCATINE, 1950. Muscatine businesses capitalized on the town's standing as the "Pearl Button Capital of the World." The Batterson Store offered a one-year supply of Pearl City Hosiery to the person who came closest to guessing the number of button blanks in the jar (lower, right corner). (Courtesy of Musser Public Library.)

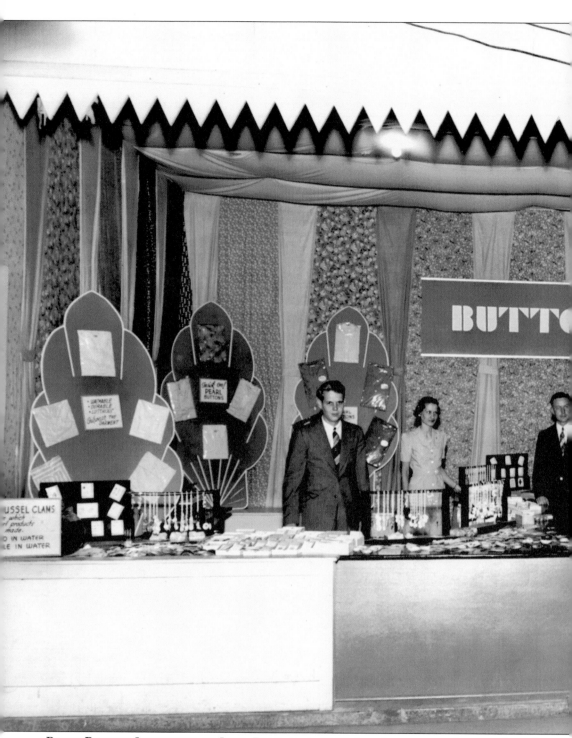

PEARL BUTTON INDUSTRIES OF IOWA DISPLAY, C. 1940. Iowa button manufacturers formed an alliance to help promote their products to the rest of the world. The group consisted of seven Muscatine companies, including Automatic Button Company, Hawkeye Button Company, Iowa Pearl Button Company, McKee Button Company, Muscatine Pearl Works, U.S. Button

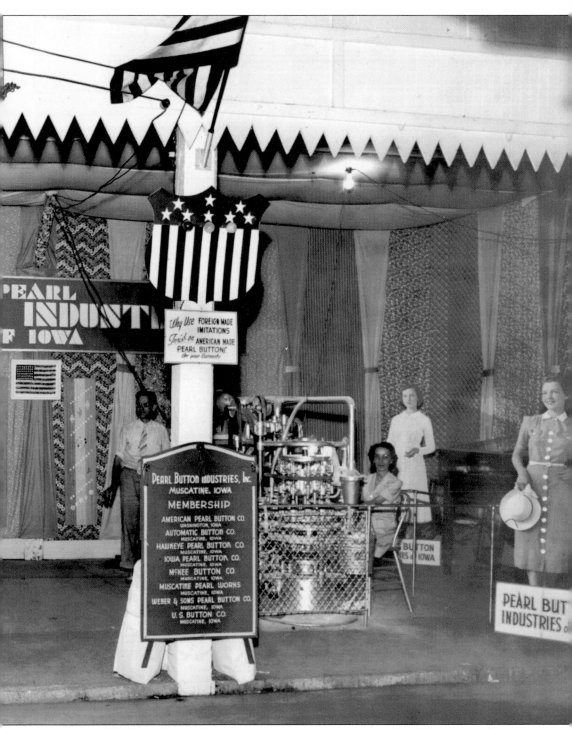

Company, and Weber and Sons Button Company, and one company from Washington, Iowa—American Pearl Button Company. Mercedes McKee became a familiar face at pearl button trade shows. By 1938, cutouts of McKee marketed the McKee brand. Her husband, Donald Allbee (far left), worked this trade show. (Courtesy of Muscatine History and Industry Center.)

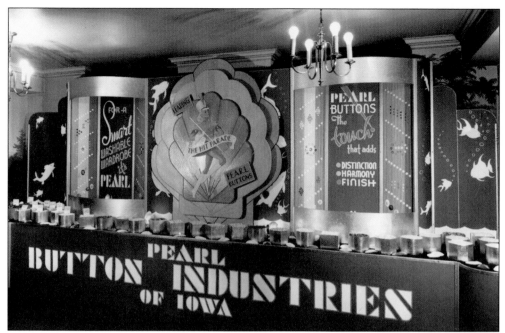

TRADESHOW BOOTH, C. 1935. The eight member companies of Pearl Button Industries of Iowa produced informational booklets on button making in addition to highlighting their wares at shows. One of their publications, "An Adventure of a Pearl Button," provided details from harvesting mussels to carding finished buttons. (Courtesy of Muscatine History and Industry Center.)

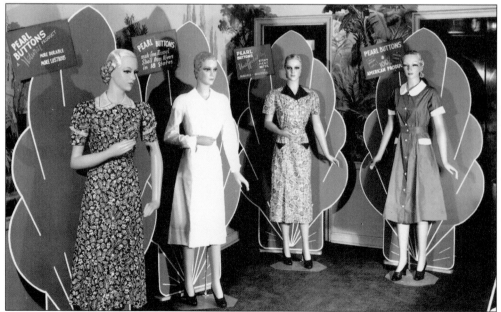

MANNEQUINS IN DRESSES WITH PEARL BUTTONS, 1930S. Button manufactures touted pearl as more durable, more lustrous, beautiful, and unaffected by steam, heat, and water. Manufactures also advertised that their buttons were "made from mussel shells from rivers in 18 states," and "a 100% American Product." (Courtesy of Muscatine History and Industry Center.)

Eight

BEYOND BUTTONS

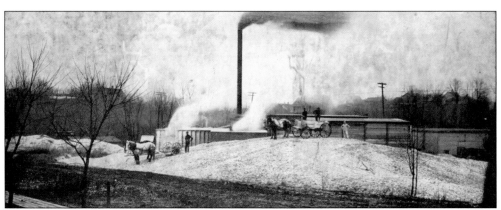

SHELL PILE AT HAWKEYE BUTTON COMPANY, C. 1905. Tons of leftover shells accumulated around Muscatine's cutting shops and button factories. In some instances, the finished button made up as little as 10 percent of the original shell. Not all shell cutters were skilled at obtaining every usable blank. (Courtesy of Charles and Shirley Hagermann.)

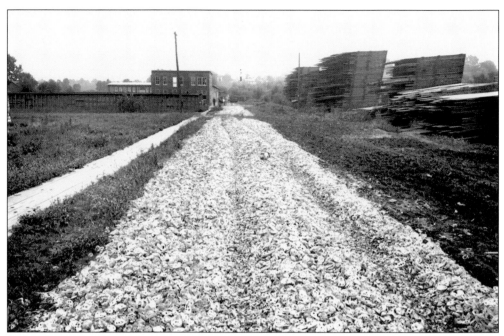

SHELL ROAD TO THE LEO HIRSCH BUTTON COMPANY, C. 1902. Factories and cutting shops wondered what to do with the leftover shell and shell dust. Some began paving alleyways with cut shell and using it as fill. The Leo Hirsch Button Company was located at 809 East Fourth Street. (Courtesy of Musser Public Library.)

SHELL DUST BAG, HAWKEYE BUTTON COMPANY, c. 1910. Button factories also collected shell dust. Many of the machines, such as the Double Automatic, had suction devises that trapped shell dust. Charles "Mick" Hagermann recalled using "button dust" as a natural insecticide on pumpkin patches. (Courtesy of Muscatine History and Industry Center.)

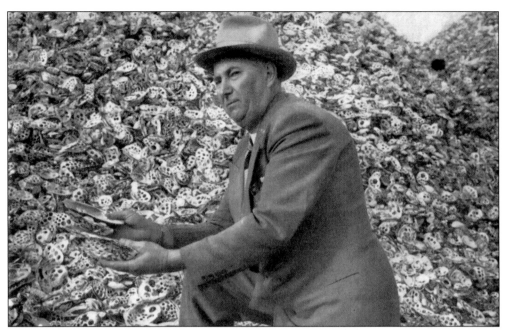

GEORGE GEBHARDT WITH A PILE OF CUT SHELLS, 1950. A little experimenting led to the development of marketable by-products. Muscatine native George Gebhardt saw potential in the leftover shell. His Universal Shell Company became a half-million-dollar-a-year business. Gebhardt's creative thinking, along with persistent marketing, turned waste into wealth. (Courtesy of Muscatine History and Industry Center.)

UNIVERSAL SHELL COMPANY ADVERTISEMENT, c. 1950. Farmers had already discovered numerous applications for shell chips and dust, using it as a natural insecticide and grit for chickens. Early on, factories gave their waste materials to anyone who would haul it away. Gebhardt discovered that shell dust could be used as a mineral supplement for all types of animals. (Courtesy of Muscatine History and Industry Center.)

COLORED SHELL PIECES, C. 1950. George Gebhardt realized that dyed shell pieces looked attractive in the bottom of fishbowls and as decoration in flowerpots. Marilyn Jackson of Muscatine recalled working for Gebhardt: "During the summer between my junior year and senior year in high school, George Gebhardt had a factory down by the river called Universal Crushed Shell. And George was a very innovative person. He could think of all kinds of ways to use materials that had been discarded by other people. And he would take pieces of the shells that buttons had been made out of and cut them up small and dyed them pretty colors for putting into goldfish bowls. That was one of his products that sold in five and ten cent stores around the country. . . . George used every bit of the product." He also used shell pieces in stucco and the fine powder to line football and baseball fields. (Courtesy of Muscatine History and Industry Center.)

DRAWING OF DESIGNS FOR NOVELTY ITEMS, C. 1940. Muscatine made more from mussel shell than billions of buttons. Ordinary items such as fishing lures, tableware, coin purses, candlesticks, and other novelties became treasured pieces when made from iridescent shell. These designs are from the Muscatine Pearl Works. (Courtesy of Ann Moody.)

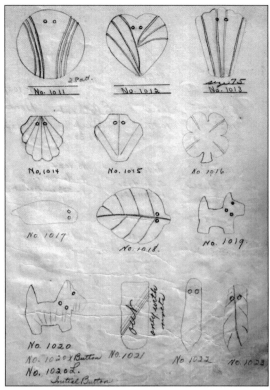

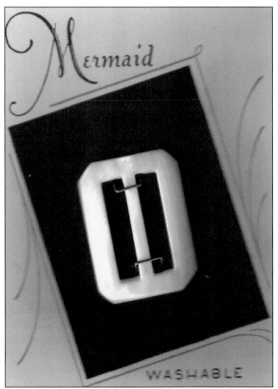

BUCKLE ON MERMAID BRAND CARD, C. 1920. Other shops turned shell parts, unusable for buttons, into jewelry and accessories. Companies in Muscatine worked with both freshwater mussel shell and ocean shell. Some companies became specialists in manufacturing belt buckles while others produced sequins, hat pins, tie tacks, and more. This buckle was made by the Hawkeye Button Company. (Courtesy of Muscatine History and Industry Center.)

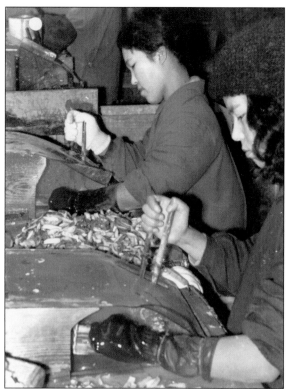

TURNING SHELL INTO CULTURED PEARL, C. 1970. As the pearl button industry declined in the 1950s and eventually ended in the 1960s, North American shell, particularly the washboard, became highly prized for use in cultured pearl production. Thousands of tons of freshwater mussel shell were sold to Japan for the cultured pearl industry. Tiny beads of shell, when implanted into oysters, transforms over one or two years into valuable pearls. (Courtesy of Muscatine Art Center.)

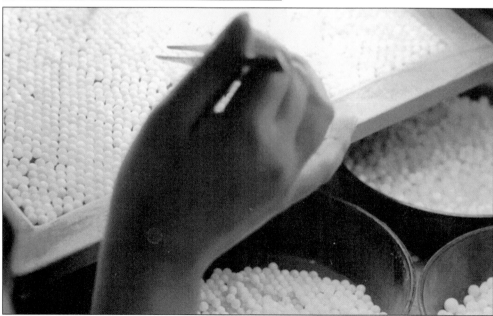

TURNING SHELL INTO CULTURED PEARL, C. 1970. To prepare a "seed" for cultured pearls, mussel shells were first cut with a circular saw blade into long slices. The long slices were turned into cubes. The cubes were ground into circular beads and polished. Workers then removed beads with irregularities in shine or color. The desirable beads were then implanted into oysters. (Courtesy of Muscatine Art Center.)

Nine

MORE FUN THAN A BARREL OF BUTTONS

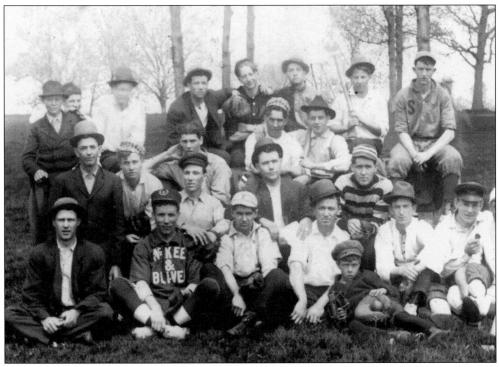

McKee and Bliven Baseball Team, c. 1910. Although a day's work in the button business could be long and repetitive, larger companies offered workers opportunities for recreation. Team sports were among the most popular activities and lead to better relationships within the factories. (Courtesy of Nancy Keel.)

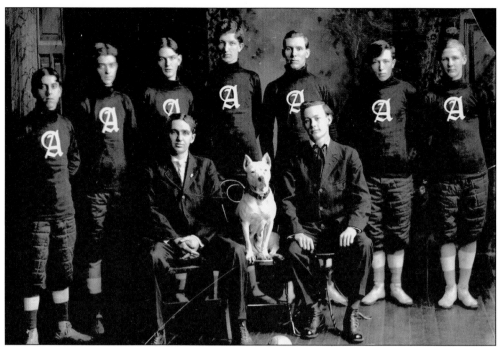

INDOOR BASEBALL TEAM, C. 1910. The Automatic Button Company's indoor baseball team played against other local companies. Company sports teams became more popular in the 1920s and later. (Courtesy of Musser Public Library.)

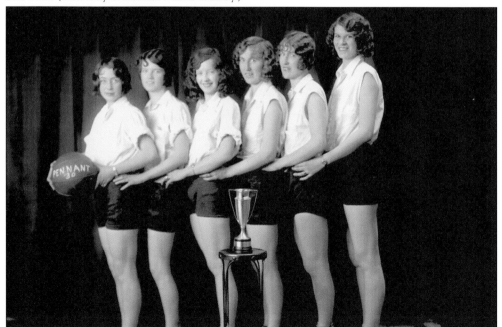

WOMEN'S BASKETBALL TEAM, 1930. Women participated in company-sponsored sports. This photograph shows the Pennant Button Company's women's basketball team. Other women's basketball teams included Iowa Pearl Button Company, Muscatine Aces, McColm Company (dry goods store), and the telephone company. (Courtesy of Musser Public Library.)

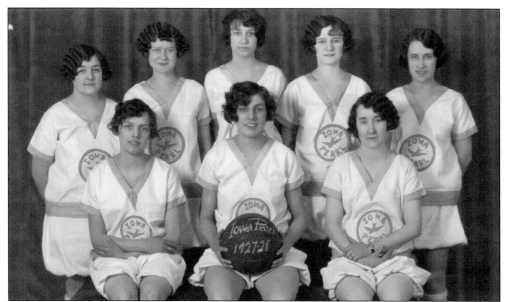

WOMEN'S BASKETBALL TEAM, C. 1929. Pictured is the women's basketball team from the Iowa Pearl Button Company. From left to right are (first row) Dorothy Vanysseldyk, Grace Meerdink, and Gertrude Oberhaus; (second row) Genevieve Facks, Blanche Wardlow, Margaret Jensen, Lillian Facks, and Mildred Crow Ziegenhorn. The Iowa Pearl Button Company uniforms featured a blue bird—the same design used on its carded buttons. (Courtesy of Muscatine History and Industry Center.)

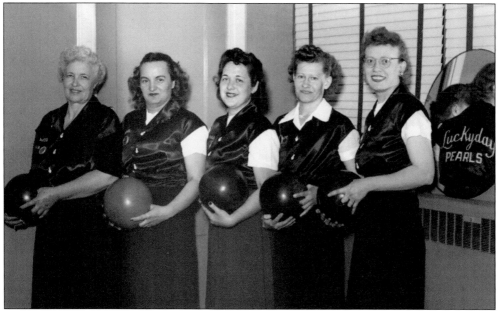

LUCKYDAY WOMEN'S BOWLING TEAM, 1947. Muscatine Pearl Works sent its women's bowling team to a Grand Rapids, Michigan, tournament in 1947. The mirror in the background shows the company's name brand, "Luckyday Pearls," embroidered on the uniforms. Pictured, from left to right, are Ethel Anen, Gwendolyn Meltzer, Harriet Shomberg, Jeanette Bartkus, and Iris Bauerbach. (Courtesy of Muscatine History and Industry Center.)

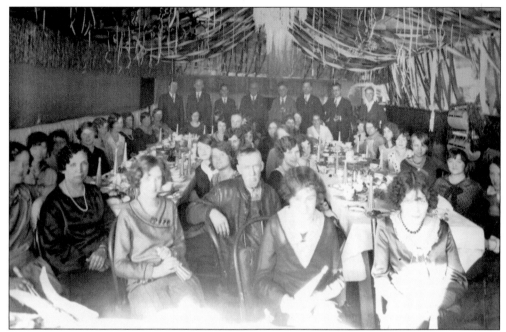

CHRISTMAS PARTY, 1928. The occasional party boosted employee morale. Some workers formed bonds that even outlasted the pearl button industry and organized reunion events for former button company employees. This photograph shows workers from the Iowa Pearl Button Company. (Courtesy of Muscatine History and Industry Center.)

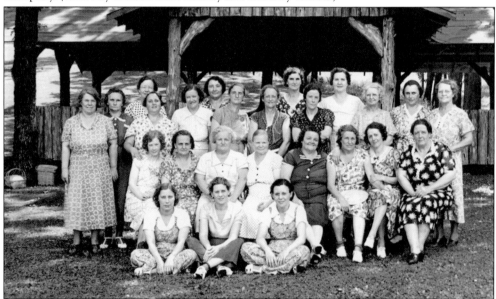

PICNIC IN WEED PARK, 1938. Identified here are Dorothy Dye, Violet Mockmore, Georgia Jabker, Fannie Liebbe, Edna Bardau, Tille Hasse, Sylva Golightly, Grace Smith, Verna Graham, Mary Dittman, Pearl Reifert, Leila Edwards, Jessie Brown, Ada Cracraft, Lulu Brendel, Emma Scholten, Lydia Bryant, Zula Butcher, Myrtle Steckman, Emma DeLong, Hattie Hartung, Adelaide Lewig, Pearl Crow, Ruth Jefferson, and Lena Gundrum. These women worked for Iowa Pearl Button Company. (Courtesy of Muscatine History and Industry Center.)

LUCKYDAY NEWS AND VIEWS, **1945.** The Muscatine Pearl Works's monthly employee bulletin included cartoons, jokes, safety reminders, company news, and employee spotlights. Claus Schmarje, who served as secretary, was the featured person of the month. (Courtesy of Muscatine History and Industry Center.)

AMONG OURSELVES

AUGUST, 1945

SPOTLIGHT OF THE MONTH

The spotlight this month is on our secretary, Claus Schmarje. Success story is a term that can readily be applied to the business career of Claus. Born in Germany he came as an immigrant boy of 15 to Muscatine. The first year he was employed in a Box Factory at the princely wage of $6 for a 60-hour week. He then started cutting buttons, and worked at that job until 1916 when he started a button blank shop. He operated this until 1935, when he became associated with the Muscatine Pearl Works, of which he is secretary.

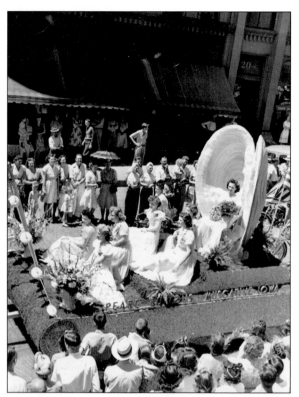

BUTTON QUEEN FLOAT, 1946. Muscatine button factories came together to celebrate the 50th anniversary of the button industry and Iowa's centennial. On July 4, 1946, seven young women employed by the button industry sat atop a float with a giant mussel shell. Each represented one of the major button factories in Muscatine and hoped to be crowned Pearl Button Queen. (Courtesy of Muscatine History and Industry Center.)

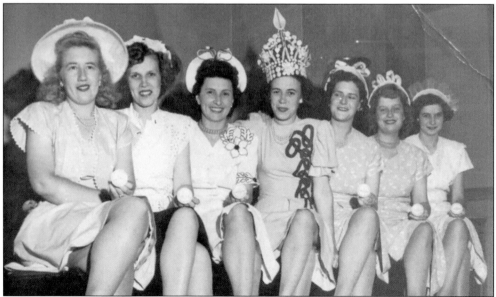

BUTTON QUEEN CANDIDATES, 1946. Members of the pearl button court included, from left to right, Florence Reinier of Iowa Pearl Button Company, Norma Brown of Hawkeye Button Company, Lucy Smith of Perkin's Button Company, Helen Burke of Automatic Button Company, Kathleen Neff of McKee Button Company, Juanita Phillips of Muscatine Pearl Works, and Dorothy Wilder of Weber and Sons Button Company. (Courtesy of Muscatine History and Industry Center.)

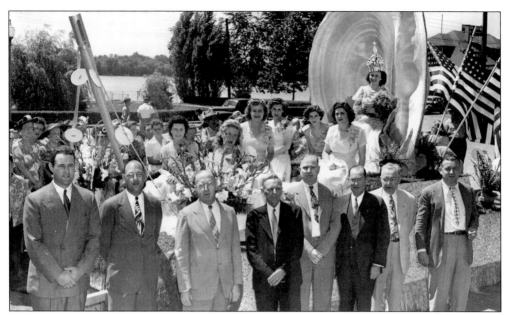

BUTTON QUEEN COMMITTEE, 1946. Representatives from the button companies made up the committee for the industry's 50th anniversary celebration. From left to right are Richard Hines of Muscatine Pearl Works, Leonard Weber of Weber and Sons Button Company, Rollie Scholten of Iowa Pearl Button Company, Charles Hagermann of Hawkeye Button Company, William Umlandt of Automatic Button Company, Harold McKee of McKee Button Company, William Hilton of McKee Button Company, and George Patterson of Perkin's Button Company. (Collection of Muscatine History and Industry Center.)

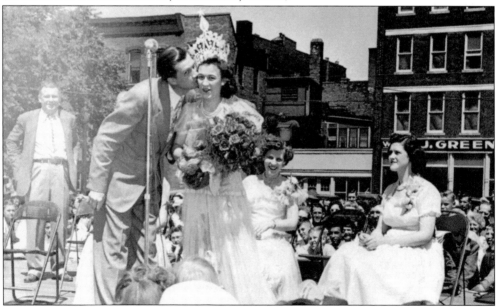

DON WALKER AND BUTTON QUEEN HELEN BURKE, 1946. While then-actor Ronald Reagan selected the queen from photographs, Don Walker of Warner Brothers had the honor of crowning the queen. Walker gave Helen Burke a congratulatory kiss after she received the crown. (Courtesy of Muscatine History and Industry Center.)

HELEN BURKE, MUSCATINE'S BUTTON QUEEN, 1946. Ronald Reagan had sent his congratulations to the queen by telegram: "Choosing a winner from the seven attractive contestants for the Muscatine button queen crown was one of the toughest assignments I ever tackled. I have selected Helen Burke, but want to add my sincere congratulations to all the girls. As a former Iowan I want to wish Muscatine a very happy 50th anniversary of the founding of the button industry. . . . Thanks for the priviledge of selecting the queen." Helen Burke recalled the thrill of being selected button queen in a 1981 *Muscatine Journal* article: "I couldn't believe it! George Patterson took me by the elbow and escorted me to the microphone on the stage. They gave me a big bunch of roses and put a crown on my head—and I immediately fainted! I don't think I passed completely out but for a few seconds the shock and surprise overcame me. I was absolutely thrilled to think that Ronald Reagan had chosen me!" (Courtesy of Muscatine History and Industry Center.)

BIRTHDAY CARD, C. 1940. The Muscatine Pearl Works gave birthday cards to its employees. Freda George, who worked at J and K Button Company noted, "It's just like a family. Back then, you'd go into a place and work. If you did your work good and were as nice as you could be, you were just like family." (Courtesy of Muscatine History and Industry Center.)

Ten

END OF THE PEARL ERA

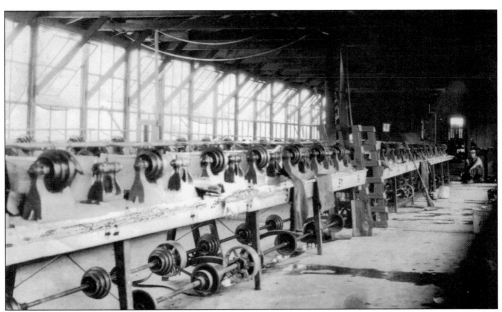

CUTTING SHOP, C. 1940. The industry that was so firmly rooted in Muscatine could not continue in perpetuity. The 1930s and 1940s brought the end of major factories such as the U.S. Button Company and Pennant Button Company and the close of over a dozen long-running cutting shops. (Courtesy of John Miller.)

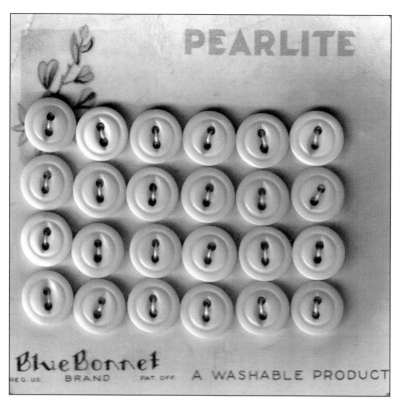

PEARLITE BUTTON CARD, 1950. Early experiments with plastic buttons began in the 1920s. During World War II, technological advancements brought better plastic buttons. Touted for their pearl-like qualities, plastic buttons attempted to provide the look of pearl at a fraction of the cost. (Courtesy of Muscatine History and Industry Center.)

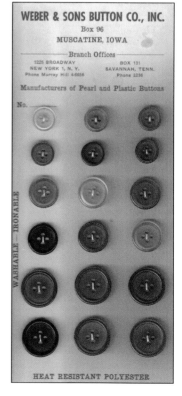

WEBER AND SONS SAMPLE CARD, C. 1958. The switch from pearl to plastic did not occur over night. In the 1950s and 1960s, many Muscatine factories made freshwater pearl, ocean pearl, and plastic buttons simultaneously. The Barry family's Double Automatic machine was adapted to finish plastic button blanks. (Courtesy of Muscatine History and Industry Center.)

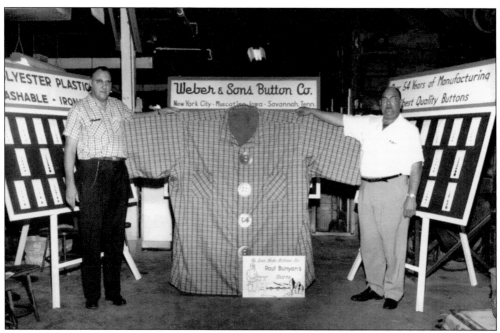

LEONARD WEBER AND LOUIS WEBER, C. 1958. Generations of Webers learned the button business. Over a century later, company founder John Weber's descendents continue the family tradition. In 1955, the company made its first acrylic button, switching to polyester two years later. (Courtesy of Weber and Sons Button Company)

WEBER AND SONS BUTTON COMPANY LOGO. Weber and Sons Button Company was one of several Muscatine companies to make the switch from pearl to plastic. A number of factors caused the decline of the pearl button industry. Labor expenses, limited availability of shells, foreign competition, changes in fashion, zippers, and the development and refinement of plastics made it impossible for companies to earn a profit from pearl. (Courtesy of Weber and Sons Button Company.)

J and K Button Company, c. 1970. J and K Button Company was Muscatine's first button factory dedicated entirely to plastic. In 1956, button veteran William Umlandt and his son-in-law Bernard Hahn launched the factory in the old Iowa Pearl Button Company building on Mississippi Drive. (Courtesy of J and K Button Company.)

J and K Button Company Logo. William Umlandt started the factory in the old Iowa Pearl building and named the company after his granddaughters Janet and Kay. Umlandt was quoted as saying, "I've always stood up for the pearl button, but I've got to say, and with great regret, that the plastic button is a better button." (Courtesy of J and K Button Company.)

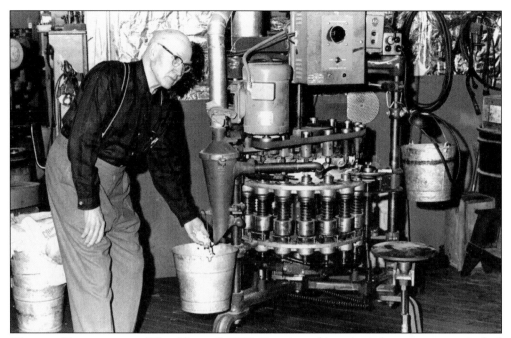

WILLIAM UMLANDT AND "THE HORSE," 1966. Even in making plastic buttons, companies had to adapt to compete with foreign manufacturers. Umlandt invented "The Horse"—a machine that could face or drill a button at two-and-a-half to four times the speed of ordinary equipment. (Courtesy of J and K Button Company.)

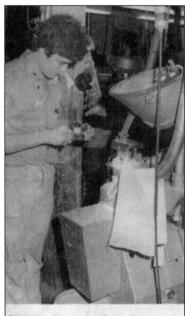

J & K Button Co., Inc.

Bill McGowan checks a plastic button at the J & K Button Company factory. Buttons are made here, by the millions, for shipment to clothing manufacturers.

THE FAMILY BUSINESS. Bernard Hahn's grandson Bill McGowan and son-in-law Ron McGowan kept up with innovations in button making. When J and K Button Company bought out an East Coast company in 2005, they acquired machines that produced the most intricate designs and largest sizes made in the United States. (Courtesy of J and K Button Company.)

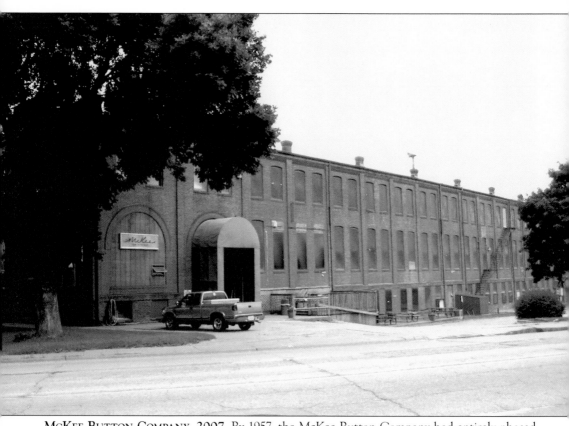

MCKEE BUTTON COMPANY, 2007. By 1957, the McKee Button Company had entirely phased out pearl buttons. Ted McKee commented in a 1982 *Muscatine Journal* article, "We employed 500 people at one time, and that's when there were a lot of button makers here." At the time of the article, McKee served as president of the company that employed about 70 people. Although it employed far fewer workers, McKee Button Company was producing between 60,000 and 100,000 gross of buttons each week in the 1980s. The production at McKee was half that amount at the peak of the pearl button industry. The automated machines used in making plastic buttons replaced the workers needed to handle each pearl button individually. With plastic, a few employees were all that was required to oversee the various steps of the machining process. (Collection of Muscatine History and Industry Center.)

TED McKEE, C. 1982. Four generations of McKees have developed innovative products and machinery. In the 1960s, McKee developed the Buttonmatic, a machine that automatically feeds and sews buttons onto garments. (Courtesy of Muscatine History and Industry Center.)

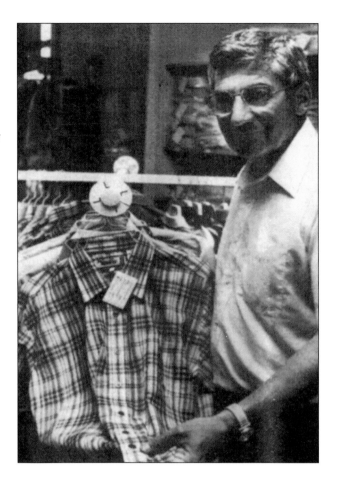

McKEE BUTTON COMPANY LOGO. McKee Button Company and other Muscatine companies manufacture polyester buttons. Polyester, in the form of syrup, is mixed with a catalyst and shaped into a flat sheeting using centrifugal force. A die cuts button blanks from the newly-formed, semi-flexible sheet of plastic. The blanks are automatically fed into machines that carve the design and drill the holes in the button. (Courtesy of McKee Button Company.)

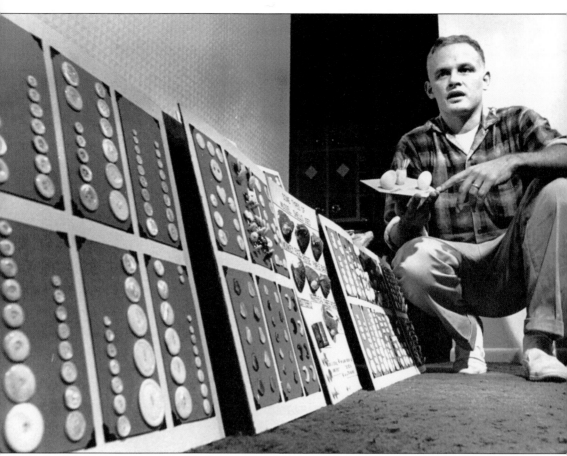

JOE MARSHEK WITH HIS BUTTON COLLECTION, 1967. As the pearl era came to a close, people in Muscatine wondered what would become of all the unsold pearl buttons. Dick Hines of the Muscatine Pearl Works began stockpiling pearl buttons. Even though his company stopped production of pearl, it continued to offer consumers a wide range of genuine pearl. Collectors such as Joe Marshek and his wife, June (Weber), wanted to gather samples of each type of pearl button and novelty manufactured in Muscatine. The couple mounted fancy pearl buttons and other items on black velvet and later donated their collection to the Pearl Button Museum—the predecessor of the Muscatine History and Industry Center. (Courtesy of Muscatine History and Industry Center.)

HOME-O-NIZE BUILDING, 1950. Muscatine faced the problem of what to do with the many buildings that once housed pearl button factories. The Home-O-Nize Company purchased buildings of the Automatic Button Company, Hawkeye Button Company, Pennant Button Company, and the U.S. Button Company. In addition to finding use for the buildings and land, Home-O-Nize employed many former button workers. (Courtesy of HNI Corporation.)

HNI CORPORATION HEADQUARTERS, MUSCATINE, 2007. Founders C. Maxwell Stanley, Clem Hanson, and H. Wood Miller probably never dreamed that the company they began in 1944 would become the world's second largest manufacturer of office furniture. From Home-O-Nize to HON Industries to HNI Corporation, progress has not interfered with the value the company places on its "members"—the designation given to employees. (Courtesy of HNI Corporation.)

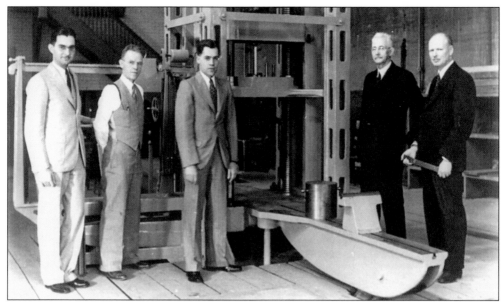

C. MAXWELL STANLEY, 1928. Fortunately for Muscatine, a number of businesses established themselves as the pearl button industry declined. The Stanley Group traces its beginnings to 1913, when Central States Engineering launched its practice in Muscatine. When C. Maxwell Stanley (third from left) joined the two-person firm in 1932, the name Young and Stanley Incorporated was adopted. (Courtesy of The Stanley Group.)

HEADQUARTERS OF THE STANLEY GROUP, 2007. Following the retirement of business partner Charles Young in 1938, the name changed to Stanley Engineering Company. Growing at a steady pace, employee numbers reached 163 in the late 1940s. By 2007, The Stanley Group employed 1,500 people worldwide with 15 offices in the United States. (Courtesy of The Stanley Group.)

KENT FEEDS, C. 1945. Kent Feeds was among the businesses that grew in Muscatine even as pearl buttons continued to be produced. Gage A. Kent had begun a feed mill in Indianola in 1927 and moved the business to Muscatine in 1936. A modern feed plant was built in Muscatine in 1952 with additional operations opening in Iowa, Illinois, Indiana, Missouri, Nebraska, Kentucky, and Michigan. (Courtesy of Muscatine Foods Corporation.)

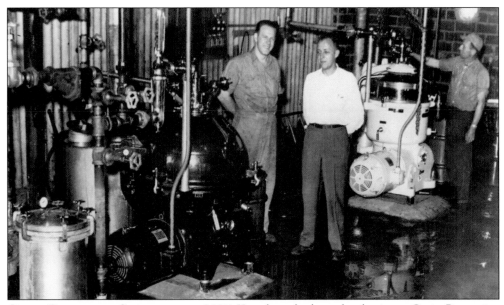

GRAIN PROCESSING CORPORATION, 2007. Kent launched another business, Grain Processing Corporation (GPC), in Muscatine in 1943 with prominent businessman S. G. Stein. The corn processing plant originally produced synthetic rubber to meet wartime demand. Following World War II, the plant produced industrial and beverage alcohol, starch, and maltodextrins. After opening a second plant in Washington, Indiana, in 1999, GPC established itself as one of nation's largest corn processors. (Courtesy of Muscatine Foods Corporation.)

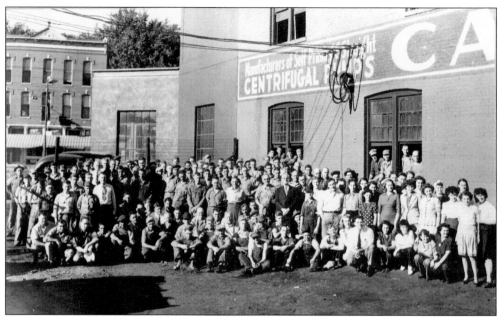

CARVER PUMP EMPLOYEES, C. 1951. Roy J. Carver began manufacturing self-priming pumps in Matherville, Illinois, in 1938. As World War II began, the demand for pumps used in naval ships increased, and Carver established a larger facility in Muscatine. Carver Pump has traditionally built pumps for water, oil, and chemicals for both the public and private sectors. (Courtesy of Carver Pump Company.)

BANDAG EMPLOYEE, C. 1960. Carver launched a second company in Muscatine after obtaining the North American rights to a tire retreading process. Since Bandag, Incorporated began in 1957, it has grown into a global network of more than 1,300 franchised dealerships in 121 countries. Bandag became part of the Bridgestone family in 2007. Seen here is Les Thompson, applying tread. (Courtesy of Bandag Incorporated.)

MUSCATINE HISTORY AND INDUSTRY CENTER, 2006. No longer dependent upon the pearl button, a variety of industries support the Muscatine economy. The Muscatine History and Industry Center is dedicated to its mission of preserving and interpreting the many "made in Muscatine" stories. At the cornerstone of the center's exhibitions is the history of the pearl button industry. A new exhibition on the button industry opened in 2006. Other businesses and organizations in Muscatine have held onto the pearl button past from the Button Factory Wood Fire Grille and the Clam Shell Diner, to the shops at Pearl Plaza and the *Mississippi Harvest* sculpture installed on the Muscatine riverfront. Pearl buttons will remain part of the community's collective memory. (Courtesy of Muscatine History and Industry Center.)

Discover Thousands of Local History Books Featuring Millions of Vintage Images

Arcadia Publishing, the leading local history publisher in the United States, is committed to making history accessible and meaningful through publishing books that celebrate and preserve the heritage of America's people and places.

Find more books like this at
www.arcadiapublishing.com

Search for your hometown history, your old stomping grounds, and even your favorite sports team.

Consistent with our mission to preserve history on a local level, this book was printed in South Carolina on American-made paper and manufactured entirely in the United States. Products carrying the accredited Forest Stewardship Council (FSC) label are printed on 100 percent FSC-certified paper.

MADE IN THE USA